RAMESSES
LOVED BY PTAH

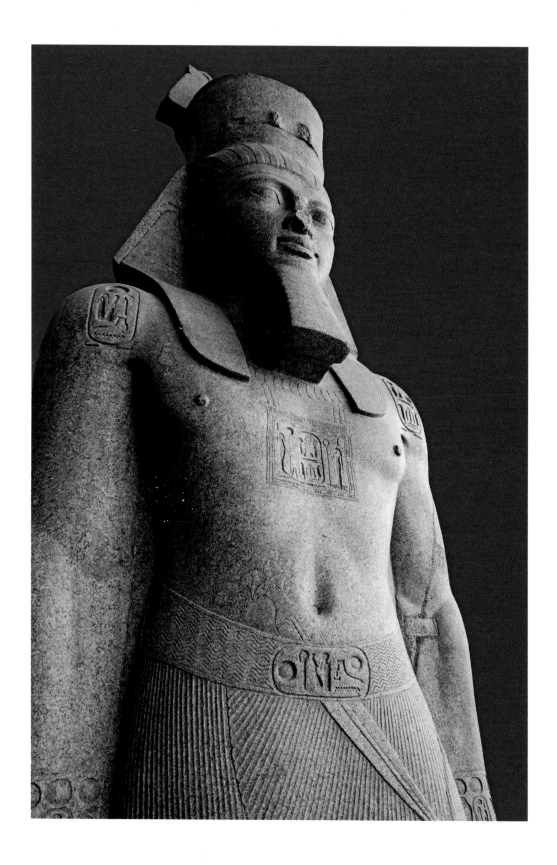

RAMESSES
LOVED BY PTAH

THE HISTORY OF
A COLOSSAL
ROYAL
STATUE

Susanna
Thomas

The American University in Cairo Press
Cairo New York

First published in 2022 by
The American University in Cairo Press
113 Sharia Kasr el Aini, Cairo, Egypt
One Rockefeller Plaza, 10th Floor, New York, NY 10020
www.aucpress.com

ISBN 978 1 649 03185 3

Library of Congress Cataloging-in-Publication Data

 Names: Thomas, Susanna, 1966- author.
 Title: Ramesses loved by Ptah: the complete history of a colossal royal statue /
 Susanna Thomas.
 Identifiers: LCCN 2022013202 | ISBN 9781649031853 (trade paperback) |
 ISBN 9781649032492 (pdf)
 Subjects: LCSH: Ramses II, King of Egypt—Statues—Egypt—Memphis (Extinct city) |
 Memphis (Extinct city)—Antiquities.
 Classification: LCC DT73.M5 T43 2022 | DDC 932/.014—dc23/eng/20220504

1 2 3 4 5 26 25 24 23 22

Designed by Jon W. Stoy
Printed in China

Contents

Acknowledgments

I have had the immense privilege of working for the Grand Egyptian Museum project during the exciting period when it emerged from sand dunes to become a fully-fledged museum for the twenty-first century. I wish to thank His Excellency Mamdouh Eldamaty, former minister of antiquities, and His Excellency Khaled El-Enany, minister of tourism and antiquities, and GEM directors Hussein Bassir, Mohamed Mostafa, Tarek Tawfik, and Eltayeb Abbas for giving me this wonderful opportunity.

I am also most grateful for the help and support of many friends and colleagues at the GEM, especially the talented designer Irina Goryacheva, who created the fine hieroglyphic font used in this book. I would like to thank Nadia Naqib and Neil Hewison at the AUC Press, and Steven Snape, Ashley Cooke, the late Geoffrey Tassie, David Jeffreys, Kei Yamamoto, Alasdair Brooks, Aidan Dodson, and Nigel Fletcher-Jones for useful comments and vital illustrations.

As the daughter of an archaeologist I grew up thinking that scanning the ground for pottery sherds at historical sites was normal, and that photographs without people in them were more useful. I would also like to thank my long-suffering daughters, who have been taken to Ramesside temples since before they could walk, and who have learned the former, if not the latter, from me.

Chronology

All dates below and throughout the book before 332 BCE are approximate.

Predynastic Period 4000–3100 BCE
Early Dynastic Period
 Dynasties 0–2, 3100–2690
Old Kingdom
 Dynasties 3–6, 2690–2150
First Intermediate Period
 Dynasties 7–11, 2150–2034
Middle Kingdom
 Dynasties 11–13, 2034–1650
Second Intermediate Period
 Dynasties 13–17, 1677–1550
New Kingdom
 Dynasties 18–20, 1550–1069
 Dynasty 18, 1550–1295
 Ahmose I 1550–1525
 Amenhotep I 1525–1504
 Thutmose I 1504–1492
 Thutmose II 1492–1479
 Thutmose III 1479–1425
 Queen Hatshepsut 1473–1458
 Amenhotep II 1427–1400
 Thutmose IV 1400–1390
 Amenhotep III 1390–1352
 Akhenaten 1353–1336
 Smenkhkare 1336
 Neferneferuaten 1336
 Tutankhamun 1336–1327

 Ay 1327–1323
 Horemheb 1323–1295
 Dynasty 19, 1295–1186
 Ramesses I 1295–1294
 Sety I 1294–1279
 Ramesses II 1279–1213
 Merenptah 1213–1203
 Amenmesse 1203–1200
 Sety II 1200–1194
 Siptah 1194–1188
 Queen Tawosret 1188–1186
 Dynasty 20, 1186–1069
 Setnakht 1186–1184
 Ramesses III 1184–1153
 Ramesses IV 1153–1147
 Ramesses V 1147–1143
 Ramesses VI 1143–1136
 Ramesses VII 1136–1129
 Ramesses VIII 1129–1126
 Ramesses IX 1126–1108
 Ramesses X 1108–1099
 Ramesses XI 1099–1069
Third Intermediate Period
 Dynasties 21–25, 1069–664
Late Period
 Dynasties 26–31, 664–332
Greco-Roman Period 332 BCE – 394 CE

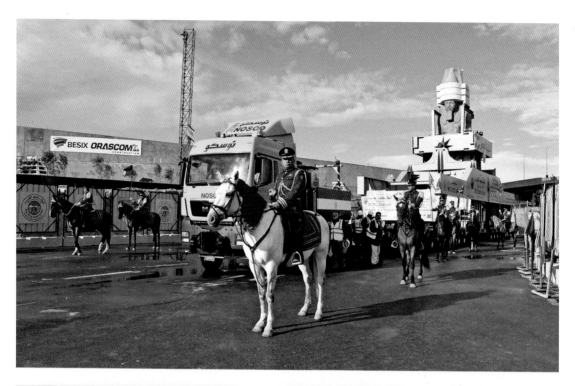

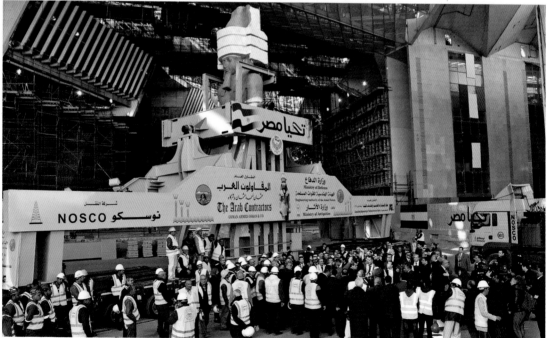

The statue of Ramesses II being moved into the Grand Hall at the GEM (photographs by B. Ezzat).

Introduction

On a rainy Egyptian Revolution Day, 25 January 2018, a large and imposing statue of King Ramesses II, accompanied by a marching band and horse-mounted escorts, was installed inside the great hall of the new Grand Egyptian Museum (GEM) next to the pyramids on the Giza plateau.

Usermaatre Setepenre Ramesses II was the third king of the Nineteenth Dynasty in the New Kingdom, when ancient Egypt was at its most powerful. The country prospered under him and experienced a period of internal and external stability. By the end of his sixty-six year reign his name was famous throughout the ancient world, and colossal statues of the king were visible in towns and cities throughout the empire. This is the story of one of those statues.

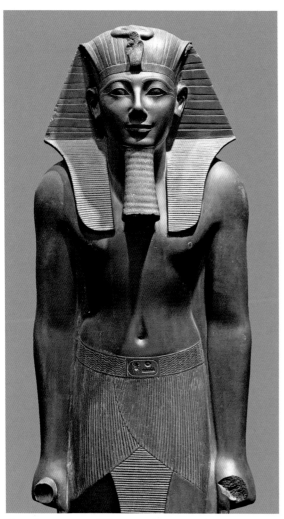

Standing statue of Thutmose III, Luxor Museum.

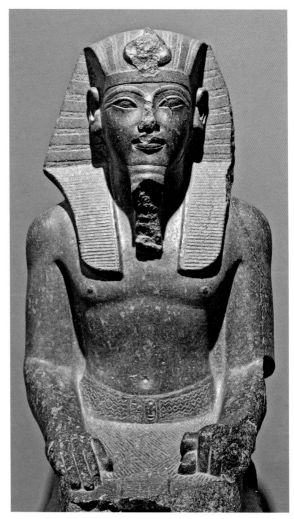

Seated statue of Amenhotep III, Luxor Museum.

1 Historical Background

The New Kingdom (Eighteenth to Twentieth Dynasties, 1550–1069 BCE) was a period of great wealth and power for the Egyptian state. Kings led military campaigns into the Levant (eastern Mediterranean lands including modern-day Israel, Palestine, Lebanon, Syria, and Jordan) and Nubia (south of Aswan in what is now southern Egypt and northern Sudan). New regions were brought under Egyptian control as the empire expanded, with exotic foreign peoples, skills, crafts, goods, and fashions flowing into Egypt. Massive building projects around the country showed off the authority of the pharaohs. There were long and glorious reigns of the Eighteenth Dynasty kings Thutmose III (1479–1425 BCE), a great military leader who expanded Egypt's empire with successful campaigns in the Levant, and Amenhotep III (1390–1352 BCE), who became famous for developing huge, elaborate, and highly decorated building projects over his whole empire, promoting the power both of the gods and of himself.

These were followed by reforms under King Akhenaten (1353–1336 BCE) that led to internal religious and political turmoil. Destruction of evidence under later kings means that many specific details of this period of history are unclear, but it is known that Akhenaten's reign was ultimately followed by that of Tutankhamun (1336–1327 BCE), who died childless and was succeeded by the elderly Ay (1327–1323 BCE), who also died without heirs and was in turn succeeded by his army commander Horemheb (1323–1295 BCE), who was the last ruler of the Eighteenth Dynasty.

Ramesses II's grandfather Ramesses I was a general and vizier (chief minister) under the childless Horemheb, and was also Deputy of the King in Upper and Lower Egypt, and the transition of power to a new family seems to have been a peaceful one. Ramesses's eldest son Sety was already an adult soldier by this time, married to Tuya, who was also from a military family. They had one son also called Ramesses, as well as two daughters.

Horemheb died in around 1295 BCE, and the first royal act of the first ruler of the Nineteenth Dynasty, King Ramesses I (1295–1294 BCE), was to oversee his burial in the Valley of the Kings (in tomb KV57) on the west bank of the Nile at Luxor. The most important god in Egypt during the New Kingdom was Amun-Re, and his main cult center was the Great Temple of Amun at Karnak in Luxor. While still in Luxor, Ramesses I and his son Sety planned fabulous additions to this temple by adding a huge courtyard of enormous columns (the hypostyle hall) between two existing pylon gateways.

Unlike the kings of the Eighteenth Dynasty, whose families originally came from Upper (southern) Egypt, Ramesses's family came from the northeast corner of the Nile Delta. Ramesses I probably already had a home near Avaris (Tell al-Daba), where the Hyksos kings of the Second Intermediate Period had lived. The Hyksos ('rulers from hill countries') were settlers, originally from the Levant, who had gradually moved into the Delta during the Middle Kingdom. Egyptians—ancient and modern—usually feel particular loyalty to the town or area where they were born, and it is likely that Ramesses also planned developments in this region. However, after about a year in office, Ramesses I died and was succeeded by his son, who became Sety I (1294–1279 BCE).

King Sety's first task was the burial of his father. Craftsmen in the Valley of the Kings had not had enough time to complete the tomb of Ramesses I to its original design, so in the seventy days traditionally set aside for the embalming process a much smaller version of the tomb planned for him (KV16) was quickly finished.

Sety and his son Ramesses, by now aged about eight or nine, sailed south from the ancient capital city of Memphis (at modern-day Mit Rahina, south of Cairo), to Luxor accompanying the mummified body of Ramesses I. After the funeral Sety selected sites for his own tomb and his mortuary cult temple on the west bank at Luxor. He checked on building works at Karnak, ordering that the new hypostyle hall should now be called 'Glorious is Sety in the domain of Amun' and that the outside walls of the hall (which more people would see) should be covered in scenes of the king defeating his enemies in battle.

Back in Memphis Sety ordered improvements to the Great Temple of Ptah, which included a massive new hypostyle hall to be called 'Glorious is Sety in the domain of Ptah.' He also made new additions to the Great Temple of the sun god Re at Heliopolis, northeast of modern Cairo. His home town was not forgotten, and he ordered the construction of a fine summer palace decorated with blue and white tiles at Avaris.

Throughout his reign, Sety modeled himself on two rulers from the Eighteenth Dynasty, the great warrior king Thutmose III and the great builder king Amenhotep III. By the end of his sixth regnal year Sety had successfully restored much of Egypt's empire in the Levant to the northeast through a series of campaigns known as the Northern

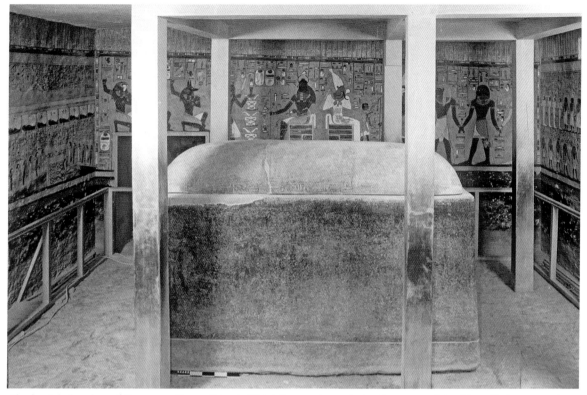

The burial chamber of Ramesses I's small tomb (KV 16) was decorated with scenes of the king offering to gods, including Osiris and a scarab-headed figure of a sun god, and scenes from a funerary text called *The Book of Gates*; his red granite sarcophagus was decorated in yellow texts (Theban Mapping Project).

Wars. He also pacified rebellions in Libya to the west and Nubia to the south. Each of his military campaigns was illustrated on newly constructed temple walls, and many included the small figure of his son Prince Ramesses, who by the age of ten was given the honorary title of Commander in Chief of the Army.

Sety continued to concentrate on building projects. Missions sent into the Eastern and Western Deserts and the Sinai Peninsula created new roads and dug new wells, allowing more quarries and mines for stone and gold to be opened.

By Year 9 of his reign, many of his new temples and temple additions were nearing completion, and more spectacular fixtures were planned for them. He and Ramesses traveled south to Aswan to see new granite quarries for obelisks and colossal statues, a visit recorded on two rock stelae by royal scribes: "His Majesty ordered to be made for himself colossal statues of black granite. Then His Majesty discovered a new quarry for big statues of black stone, whose crowns would be from the Red Mountain, the mountain of quartzite"; "His Majesty ordered a number of workmen to make great obelisks and great and wonderful statues in the name of His Majesty. He constructed large

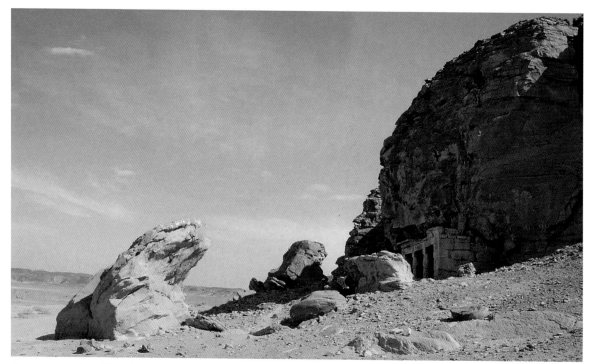

Rock-cut temple of Sety I at Kanais in the Eastern Desert. A text inside records that the king stopped at the site while inspecting mines to provide gold for his new temple at Abydos. After his long, hot journey the king declared that a well should be dug for all miners and travelers, along with a temple for them to thank the gods and the king.

Left: a stela carved into the cliff face near Aswan describing Sety I finding new granite and quartzite quarries for stone suitable for carving statues; right: a second stela near Aswan, describing ordering and shipping obelisks north under the supervision of Prince Ramesses (after Habachi 1973).

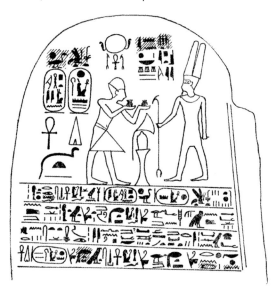

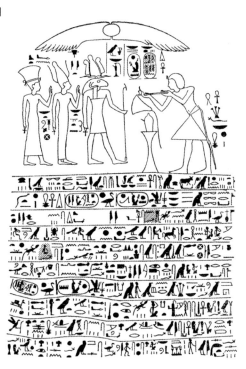

ships for transporting them, with ships' crews to match them, ferrying them from their quarry, with high officials and transport men to hasten the work along. And his senior son [Ramesses] was before them, doing good service for His Majesty."

One or more obelisks were shipped north to the temple of the sun god Re at Heliopolis. At least four colossal seated statues were sent to Luxor Temple, where a new pillared court and pylon gateway were being planned. These statues were actually left unfinished during the reign of Sety I and were later adopted and named by his son Ramesses.

King Sety died in the summer of Year 16, when Ramesses was about twenty-five years old, and after traveling south with the body of his father, Ramesses II was declared ruler in the fall of 1279 BCE.

Reign of Ramesses II

King Ramesses II (1279–1213 BCE) received four royal names at his coronation in addition to the name he was given at birth, in a practice that was introduced by at least the end of the Old Kingdom (2181 BCE). These expressed concepts of good kingship and commitment to rule the two lands of Egypt. The first three—the Horus, Two Ladies, and Golden Horus names—emphasized the new ruler's relationship with the gods. The throne name, or prenomen, also known as the *nswt bit* ('King of Upper and Lower Egypt') name, referred to the official role of the king and was the one most often used in public. Having been crowned as King of Upper and Lower Egypt Usermaatre ('Strong in Truth is Re'), during Year 2 this was expanded with the addition of Setepenre ('Chosen of Re'). His birth name (nomen), Ramesses, was written more formally as Ramesses Meryamun ('Loved by Amun'). His birth name and throne name were both encircled with cartouches (oval outlines representing a knotted rope) representing the hieroglyphic *shen* sign that meant eternal protection.

Ramesses II built more cities, fortresses, and temples throughout Egypt and Nubia than any other pharaoh, and he also took buildings and statues of previous pharaohs and renamed them as if he had ordered their construction himself. One of his primary goals was to be known and remembered as a great warrior. The image of a brave fighter single-handedly defending his kingdom was used even in his old age, and the walls of his temples were covered with inscriptions of successful military campaigns showing the king leading his troops into battle and defeating Egypt's enemies in personal combat. He had many wives and nearly one hundred children. He began his reign with two main wives, Nefertari and Isetnofret, and eventually also married some of their daughters, along with foreign princesses and other elite women. Many of these royal women are still known today through statues, inscriptions, reliefs, paintings, and the discovery of their tombs.

Kingship

For most of the pharaonic period (from 3100 BCE to 30 BCE) the king was head of the government, head of the army, and chief priest of every god in every temple. Kingship and the divine nature of the king were also central to Egyptian ideas of religion. The king was always associated with the god Horus, the son of the god Osiris and the goddess Isis. At the same time (at least from the Fourth Dynasty in the Old Kingdom onward, 2613–2494 BCE) the king was considered to be the living son of the sun god Re. Kings themselves became complete gods after death. During the Old Kingdom their soul was thought to travel to the heavens to become a god as an imperishable star, and by the New Kingdom the dead king was also thought to transform into Osiris, ruler of the underworld.

The institution of kingship was considered as coming from and being related to the gods, but it is less clear to what extent the living king himself was considered a god. Perceptions evolved and developed throughout Egyptian history, and how the king was viewed by his people seems to have varied at different times and between different social classes. It is unclear how far these concepts worried the Egyptians themselves, and in fact they seem to have been perfectly happy to believe a number of contradictory concepts and myths at the same time. Texts and images indicate that the king was treated as among the gods, and he was certainly considered their representative on earth. As other gods were responsible for various aspects of the universe (the sky, the Nile, the desert, the

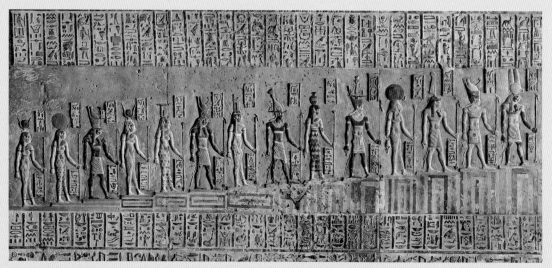

Gods and goddesses on the hypostyle hall ceiling in the temple of Hathor at Dendera: Repyt goddess of Athribis, Naunet goddess of water, Horus Behdety god of Edfu, Wadjet goddess of Lower Egypt, Nephthys goddess of protection, Horus falcon god, Isis goddess of protection, Osiris god of the dead, Nut sky goddess, Geb earth god, Tefnut goddess of moisture, Shu god of light and air, Atum god of creation, and Montu god of war.

underworld), the king's area of responsibility was the land of Egypt.

The king also mediated between the gods and the people of Egypt, and was a link between heaven, earth, and the spirits of the dead, who were thought to play an important role in everyday life. One of the most important jobs of the king was to maintain *maat*, which was an abstract concept related to truth, justice, order, balance, and rightness in the universe, and was personified by the goddess Maat, recognizable by the feather on her head.

Philosophical ideas that seem very literal to the modern viewer were based on the world that the ancient Egyptians could see around them. The sun was a ship that sailed across the great sea that was the sky. The afterlife was simply a better version of real life, where people still lived in houses with their families and worked in the fields to produce food, unless magical substitutes for servants (*shabti* figures) did it for them.

Many Egyptian concepts were also concerned with duality, and two halves making a whole was common in ancient Egyptian thought. One of their terms for Egypt was *tawy*, meaning 'the two lands.' The king was always Lord of the Two Lands (*neb tawy*), referring to the northern and southern halves of the country, and he maintained the balance between Upper and Lower Egypt. Upper Egypt is defined by the narrow ribbon of the Nile river and its fertile riverbanks flowing north between limestone cliffs, while Lower Egypt is the Nile Delta, filled with

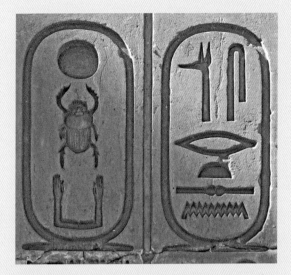

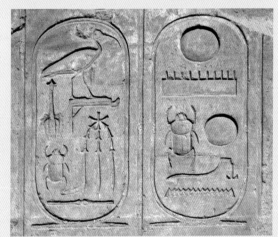

Birth and throne names of Senwosret II (Khakheperre Senwosret); and Thutmose III (Menkheperre Setepenre Thutmose Neferkheper) in protective cartouches at Karnak.

lush greenery, lakes, and marshes formed as the river splits into smaller branches fanning outward toward the Mediterranean. The king also kept balance between the ordered land of the Nile Valley and Delta (*kemet*, 'black land,' referring to the fertile soil) and the

fierce chaotic heat of the surrounding desert (*deshret*, 'red land'). Maintaining *maat* also involved balancing a number of other opposing forces such as order and chaos, light and dark, and so forth.

Kings often married more than one woman and aimed to produce a number of sons. In mythology, the parents of the god Horus were brother and sister Osiris and Isis, and their parents Geb (earth god) and Nut (sky goddess) were also brother and sister. In certain cases kings married their full sisters or half-sisters, and they also sometimes married their own daughters. This practice separated them from normal people and again associated kings with the gods.

As head of the government, the king was portrayed as the single figure who ruled Egypt. In reality, a large state bureaucracy was developed by at least the beginning of the Old Kingdom, with national, provincial, and local levels of government. The state apparatus quickly evolved and was administered by elite groups of powerful officials. Throughout Egyptian history there were a number of occasions when the system was adapted and reformed, but the king remained the titular and actual head of state.

As head of the army, kings presented and described military campaigns as a way of maintaining *maat* by defending and expanding the borders of Egypt. They also served the gods by bringing back goods from foreign countries as temple offerings. These included human prisoners of war, animals, precious

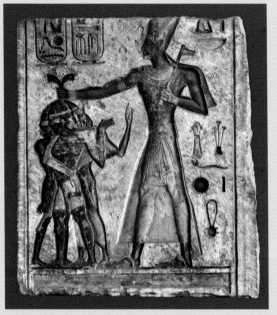

A relief from Memphis showing Ramesses II holding foreign captives and an axe (Egyptian Museum, Cairo).

metals, and exotic foodstuffs. During the Old Kingdom there was no national army, but rather expeditions sent by the king and government to achieve particular objectives. By the New Kingdom there was a large and elaborate military force, and many pharaohs were particularly keen to show themselves as armed strongmen.

As head of the priesthood, the king was responsible for every temple in Egypt, and by at least the New Kingdom it was accepted that all priests were acting on behalf of the king. A change in the perception of the god-like nature of the king seems to have occurred in the New Kingdom when, for the first time, some kings were worshiped as gods in their own lifetime, especially at the edges of the Egyptian empire.

Ramesses ruled for sixty-six years, outliving many of his wives and children, and died in August 1213 BCE aged ninety or ninety-one. In a world with high infant and childhood mortality, and where most people died well before their fortieth birthday, the king was on the throne for two, three, and even four generations of most families. His perpetual presence in the lives of his subjects must have seemed genuinely miraculous and god-like. It is hard to establish how widespread news of royal and court affairs was to the average farmer in the field, or soldiers, priests, craftspeople, and small business owners. However, from the Old Kingdom onward, taxes were collected by central and provincial administrators with an efficient communication network throughout the country, while letters and other documents tell us that many Egyptians traveled up and down the Nile for pilgrimage, business, or pleasure.

2 Egyptian Statues

gyptian art was essentially practical. The functions of statues of gods, goddesses, kings, queens, elite men and women, craftspeople, and servants were to act as representations, to be a substitute for who they were representing and also to act as a physical host for various non-physical or spiritual aspects of the entity so that they could be present and participate in rituals. The 'Opening of the Mouth' ritual seems to have been used to animate each statue and allow its soul *(ka)* to enter.

In order to operate properly, an ideal statue not only looked like the god or person it was representing but was also inscribed with their name. Statue identities could be changed by erasing and replacing the name, and facial features and other attributes were sometimes also altered.

Temple Statues of Gods

Small statues of gods formed out of precious materials were housed in temple sanctuaries and were the most important single element in any temple. From at least the Middle Kingdom onward, and gaining in popularity during the New Kingdom, these images sometimes also traveled in procession to other temples. Temple complexes often included other large wooden and stone statues of gods. During the Ramesside period there were also examples where rich private individuals included statues of gods in their tomb chapels, perhaps so the dead person and their family could worship the god from the comfort of their own tomb.

Statues of gods were not meant to be worshiped for themselves, but for the spirit of the god that was summoned and hosted inside. Personal attention to each god in the form of daily cult services was in theory carried out by the king, but in practice by high-ranking priests called god's servants *(hem netjer)*. This ritual was the most common ceremony that

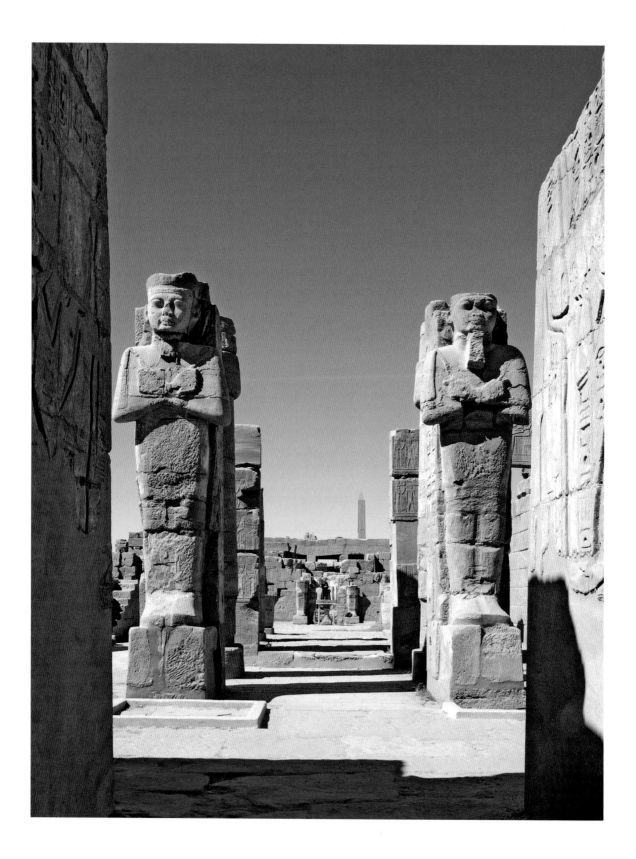

happened in every temple throughout the Egyptian empire. A typical day might include three or four visits from priests. In the morning the god's servants would purify themselves with vigorous shaving and washing. Approaching the inner sanctuary of the temple, they would first burn incense outside the sealed shrine containing the image of the god, then break the clay seal on cord tied around door knobs, open the shrine doors, bow, kiss the ground and raise arms while singing hymns, before dressing the statue in lengths of cloth and offering scented ointments and make-up, and giving him or her breakfast.

Priests would then withdraw from the room while sweeping away their footprints. Other visits occurred during the day including for lunch and supper and at the end of the day the ceremony would be repeated and the doors would be sealed for the night.

The main cult statue hidden away in each temple sanctuary was inaccessible to everyone except the king and the most senior priests and priestesses, but outer parts of temples also included more statues. These would have been visible to visitors who were allowed into at least some areas of state temple complexes on special occasions. There is debate among scholars about exactly who had access inside temples, but it is thought

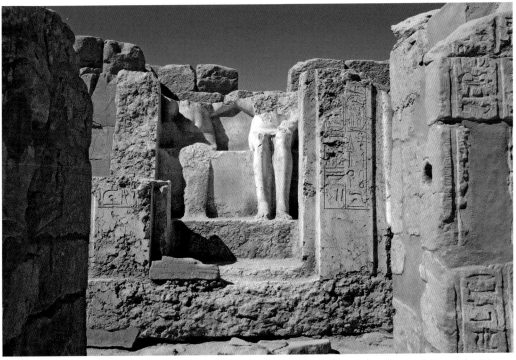

Above: figures of the god Amun (left) and King Thutmose III (right) in the shrine of One who Hears Prayers, at the east end of the Great Temple of Amun at Karnak; opposite: the temple of Amun who Hears Requests, behind the the east end of the Great Temple of Amun at Karnak (this was located outside the main temple so that anyone could come and worship there).

that a significant percentage of the urban population may have been allowed into the front areas of a temple, either while carrying out some sort of duty in administrative areas within the enclosure walls or perhaps on special occasions.

There are also examples of small shrines both near the front gate and attached to the back walls of temple complexes. These were for people to come and pray directly to the god or goddess in the temple and were named 'Place where the God Hears Requests' or 'Shrine of the Listening Ear' and some were decorated with ears for emphasis.

There is also evidence that some gods and kings were more popular than others for personal interaction on the outside walls of temples. Small holes drilled around some gods suggest that these were originally shielded by fabric tents or wooden huts to provide privacy for the worshiper.

During the New Kingdom the fashion for processions developed, when cult statues of gods were ceremonially transported from one temple to another as part of monthly or annual religious festivals. These became special occasions that gave the wider population the chance to interact with the god as it traveled past in a spectacular boat shrine. Sacred

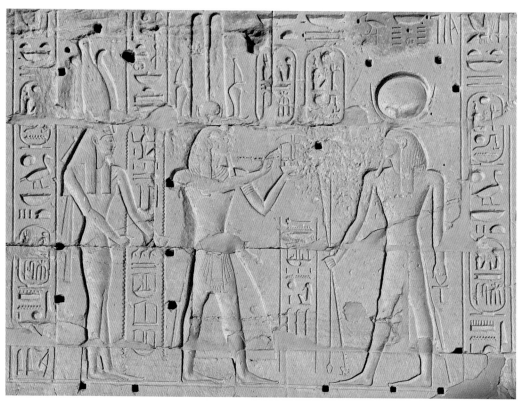

Scene of the goddess Nekhbet and King Ramesses II offering the jubilee sign to the god Thoth. Holes to hold up small tents or huts are visible around the figures of the god and goddess.

boats were ornamental boat models with curtained central cabins, and these were placed on poles and carried on the shoulders of rows of priests.

This meant that the focus of state-controlled religion became more available to the general population, at least on a limited basis. Events like the Opet festival at Thebes involved large groups of priests, temple singers and dancers, and others transporting the god's statue along newly-built processional routes from one temple to another.

Sacred sites on the other side of the River Nile might also be visited, and there are illustrations of ornamental boats transported across the river on real boats. State workers were given time off to attend the festivals, which would also have involved celebratory feasts of food and drink. Records suggest that statues remained hidden behind curtains on their travels, but there are hints that these were sometimes drawn open so that people could see within. Questions could be asked of the god, who might give a 'yes' or 'no' answer through the priests tipping or rocking the shrine, or moving it backward and forward. Even the dead were believed to participate in these festivals, and many tomb sites were placed close to, or with a good view of, processional routes.

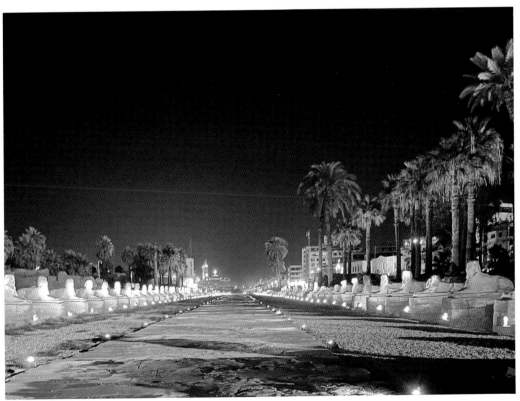

Avenue of sphinxes leading between Karnak and Luxor temples, first constructed during the New Kingdom and later renovated by Nectanebo I (380–362 BCE) who replaced the sphinxes.

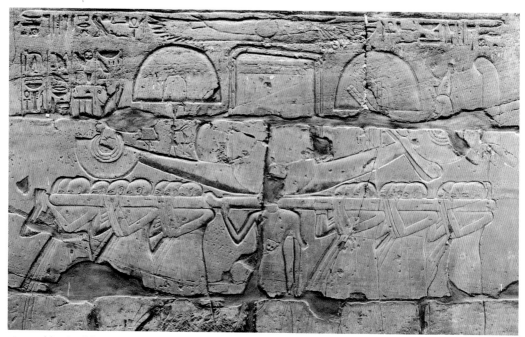

Sacred bark of the goddess Mut carried on the shoulders of priests, with her cult statue hidden inside the cabin, on the inside wall of the hypostyle hall of the Great Temple of Amun at Karnak.

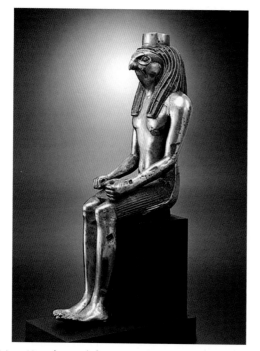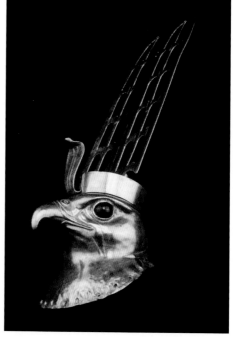

New Kingdom cult figure in silver, gold, and precious stones of a falcon-headed god (Miho Museum, Kyoto); and Old Kingdom head of the falcon god Horus (Egyptian Museum, Cairo), dating from the Sixth Dynasty (2330–2150 BCE), which was part of a statue made of different precious materials; the headdress of two feathers was added later, perhaps during the New Kingdom.

Texts tell us that cult statues were made of gold, silver, and precious stones that were thought to represent the skin, bones, and hair of the gods. Inscriptions of Ramesses II at Karnak describe new cult statues he donated to the temple: "the fashioning of an image of electrum [a mixture of gold and silver], glittering with every kind of real precious

SPOTLIGHT

Temples

Egyptian temples today are only the faintest shadow of what they once were. The bare bones of buildings remain like giant skeletons resting in the landscape. What is missing are the colors, the sounds, the smells, and the atmosphere of a living building. Used in many cases as centers of worship over thousands of years, functioning temples were like living, breathing machines dedicated to the service of the Egyptian gods. Tall stone columns and walls both inside and out were riots of blue, red, yellow, and green, while courtyards and halls were populated with colorful statues of gods, kings, and the pious elite, each receiving their own prayers and offerings. Ritual instruments were played and rattled both around and inside temples, and there was praying, chanting, and singing among priests and their attendants, temple dancers, and musicians. Tall wooden doors on copper and bronze hinges were hauled open and closed. Inner areas were rich with the various aromas of people, fragrant flowers, incense, burning wicks, spluttering wax from lamps, and food prepared for the gods. Flags fluttered on tall poles slotted into pylon gateways. Some areas had rugs or carpets, while curtains covered special images and inscriptions, and sacred statues were draped in shawls and other clothing.

There were two main types of Egyptian state temples during the New Kingdom: royal memorial and mortuary cult temples dedicated to a dead king (Mansions of Millions of Years) and those dedicated to state or local gods (Mansions of the Gods). The Egyptians used a number of different terms for temples, temple enclosures, and temple estates, including God's House (per netjer) and God's Mansion (hut netjer). This shows that the primary function of Egyptian temples was to be an actual home for the gods.

At the same time, many temples also represented the creation of the world, as inside spaces narrowed toward the back—with floors rising and ceilings lowering as they approached the inner sanctuary of the god—in imitation of the first mound of creation emerging from the lake of chaos. Tall columns representing papyrus plants and water lily blossoms growing out of a primaeval swamp held up dark blue ceilings decorated with golden stars like the night sky.

Divine statues that lived in dark spaces toward the back of temples could be activated to contain the spirit of a specific god or dead king. In theory (and in temple reliefs) these ceremonies were always carried out by the king, although in reality priests usually acted on the king's behalf.

stone to uplift his beauty for the people when he was upon three poles" and "fashioning his image with real lapis lazuli and every kind of genuine precious stone, upon four carrying-poles." Almost all were later melted down and the materials reused.

Temple Statues of Kings

Cult temples to the gods also contained statues of kings, and these were another element in the relationship between gods, kings, and the Egyptian people, as well as being directly related to the public projection of the role of the king. Old Kingdom royal annals, which listed each year's main events under the name of the king, tell of donations of temple statues of gods, paid for and dedicated by specific kings. Kings also gave statues of themselves, so allowing their soul *(ka)* to visit a temple even when they were somewhere else: until at least the beginning of the Middle Kingdom, temple complexes included specific chapels called House of the Soul *(hut ka)* to house the statue. By the New Kingdom, small black or gold statues of the king along with other gods were also placed in royal burials, the best remaining examples coming from the tomb of Tutankhamun (KV62).

Colossal royal statuary was a statement about the power of the king. Placed in front of temples, they were a visible reminder of the king's interest in the gods, his power to protect the temples and sacred space within, and his efforts to protect and maintain *maat*. This was an abstract concept related to truth, justice, order, balance, and rightness in the universe, and was personified by the goddess Maat, recognizable by the feather on her head. Without a king, Egypt would fall into chaos, which was the opposite of *maat*.

There are a few examples of the remains of colossal statues of kings from the Old Kingdom pyramid complexes in the Memphite necropolis. This is the modern name for a series of burial sites running along the desert edge on the west bank of the Nile opposite the capital city at Memphis. From Abu Rowash through Giza and Saqqara to Dahshur in the south, these cemeteries contained the burials of kings, queens, members of royal families, government figures, and other residents of the capital city. The site was in use from the First Dynasty until the Roman Period and contains more than thirty royal pyramids and thousands of mastaba (bench-shaped) and rock-cut tombs.

The largest colossal statue is the Great Sphinx at Giza, carved during the reign of the Fourth Dynasty king Khafre (2558–2532 BCE) and located at the base of the causeway in his pyramid complex. The king's head on a lion's body symbolized a magical union of strength and power. This monument is over 20 meters high and over 70 meters long.

A large head of the first ruler of the Fifth Dynasty, King Userkaf (2494–2487 BCE) was found in the mortuary cult temple of his pyramid complex at North Saqqara. The complete statue was probably once over 4 meters tall.

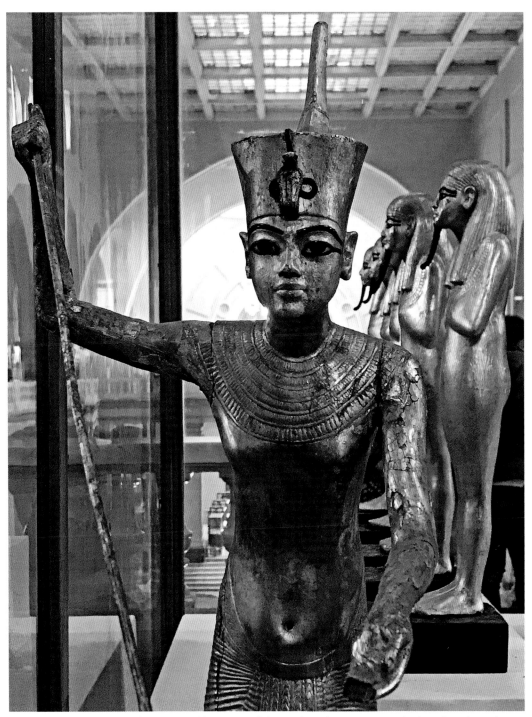

Gilded wooden statues of King Tutankhamun and the gods Geb, Tatenen, and others found inside black wooden boxes in his tomb in the Valley of the Kings (Egyptian Museum, Cairo).

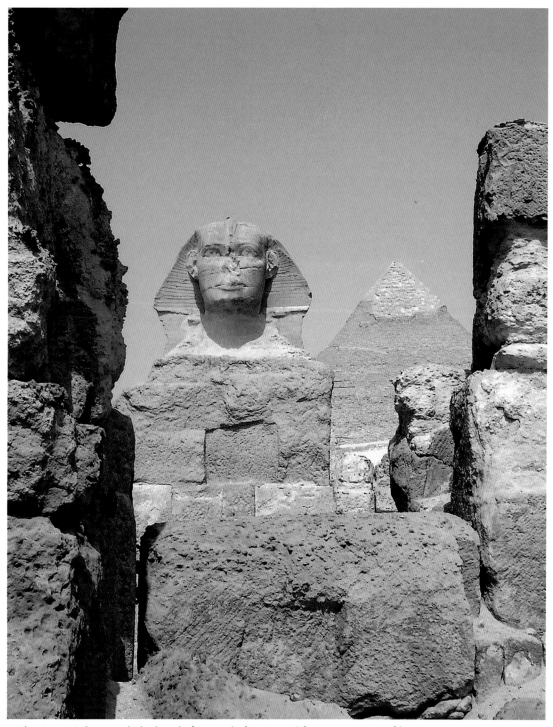

The Great Sphinx, with the head of King Khafre, carved from an outcrop of limestone at Giza.

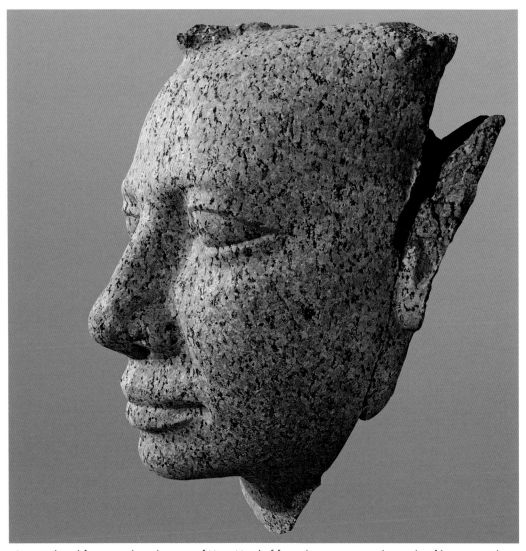

Granite head from a colossal statue of King Userkaf from the mortuary cult temple of his pyramid complex at Saqqara (Grand Egyptian Museum).

From the reign of the Middle Kingdom king Senwosret I onward (1956–1911 BCE), there seem to have been clear attempts to add colossal royal statuary in cult complexes, and a few very large royal statues of Middle Kingdom kings still survive (although most were reused by later kings). These were a visible expression of the king's presence, and also impressed onlookers with his power, wealth, and control of resources. Remaining statues generally come from temple sites, even though the buildings themselves have largely disappeared. Osiride statues of Senwosret I (shrouded like the god Osiris) were found in the

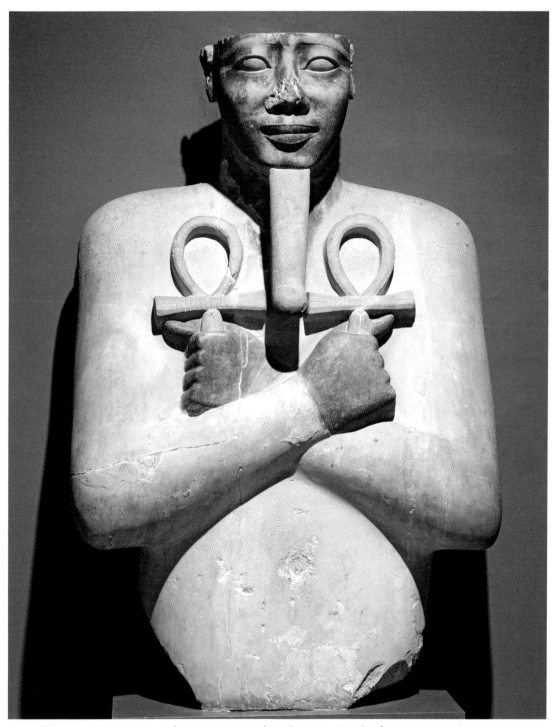

Painted limestone Osiride statue of King Senwosret I from the Great Temple of Amun at Karnak (Luxor Museum).

Two bases at Biyahmu in the Faiyum that originally supported colossal statues of King Amenemhat III.

Osiris temple at Abydos, in his pyramid complex at Lisht, and at Karnak in Luxor. At least ten large red granite statues of the same king were probably placed in front of the Ptah Temple at Memphis.

An unusual temple at Biyahmu in the Faiyum once contained two colossal seated statues of King Amenemhat III (1831–1786 BCE) overlooking the shore of Lake Moeris. Each was originally over 11 meters high, but only two 6-meter-high statue plinths and a single nose remain.

Temple expansion during the New Kingdom also included an increase in temple accessories. Tall obelisks and giant standing and seated statues of kings were placed in front of pylons and other entrances as well as inside temple courtyards, and many of these are still visible today. There are also a few examples of colossal statues of royal wives and daughter-wives accompanying their husbands.

Kings projected a faultless image of themselves. This had more than one function. Such images showed the ruler as all-powerful, and also reminded those who saw them that kings were chosen for greatness by the gods. For both ancient and modern viewers, the most obvious physical expression of kingship are the various types of royal regalia, with a number of visual signifiers that identify kings. These include crowns that were worn or used by kings (and very occasionally queens or gods). Royal statues often also had a *uraeus*, or rearing cobra, on their forehead, representing a snake that spat fire at the king's

enemies. Images sometimes showed the king holding a crook and flail to represent power and protection over Egypt. Many representations showed the king wearing an ornamental false bull tail, which demonstrated fertility and strength and also linked him to the creator god Ptah. Kings were also shown with long straight false beards hooked around their ears.

Physical representations of kings were not strictly accurate portraits in the modern sense, yet many are recognizable as specific rulers because of their particular features and attributes. This was in order that the 'perfect version' of the king could be recognized by both the gods and the people. During the Old Kingdom, kings were shown in relief and sculpture as smiling and youthful. For a brief period during the later part of the Twelfth Dynasty in the Middle Kingdom, kings were shown as tired and careworn, and this new mode was perhaps meant to show age and wisdom, although the king's body was always shown as young and strong. From the New Kingdom onward, images of the king reverted to a perfect, powerful figure with young features. The exception was during the Amarna with distorted face and features, probably to promote changes in religious philosophy and perhaps to look like Shu, the god of light and air, or maybe to represent all humanity as a male/female figure.

Statue Poses

Statues were made to be seen from the front, and almost all stone statues, and most wooden and metal ones, were carved with the subject facing forwards. This phenomenon is described as 'exhibiting frontality' and was related to the function of the statues, which was most often for either receiving or channeling prayers and offerings.

Very large statues were sometimes made to look slightly downward toward the spectator, but there are almost no examples before the Roman Period of divine, royal, or elite statues where the body bends or the head turns. More freedom was demonstrated in figures of servants, for example, where useful tasks can contort their heads or bodies.

Standing Statues with One Foot Advanced

The most common pose for standing statues of gods, kings, and elite males was with their left leg forward. For goddesses, queens, and other women their left leg was sometimes also forward, but less advanced, although surviving statues of queens before the New Kingdom are rare, and most were shown sitting down. One leg striding forward was an active pose suggesting that the figure was performing some task or ritual. Before the Middle Kingdom most stone statues' arms were shown straight down by their sides, often with their hands holding objects such as tube shapes probably representing document containers or pieces of cloth. The arms of wooden statues show more freedom, as the material was lighter and easier to carve.

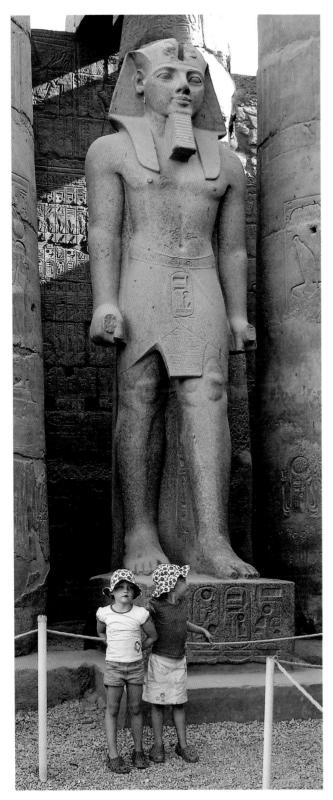

Colossal standing statue of Ramesses II in Luxor Temple, and standing statue of an unnamed Old Kingdom woman (Egyptian Museum, Cairo) with her left foot only slightly advanced, both with arms straight down by their sides.

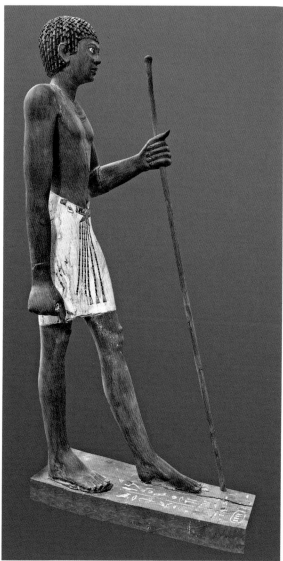

Two Sixth Dynasty statues of Niankhpepikem, Supervisor of Upper Egypt during the reign of the King Pepi I (2321–2287 BCE), showing different arm poses possible in wood (Egyptian Museum, Cairo).

By the Twelfth Dynasty a variant was introduced where the king was shown with arms slightly forward and palms flat on his kilt. This indicated that the king was praying in front of a god. Standing kings were also occasionally shown carrying or offering vessels containing ritual liquids, or other symbols to the gods.

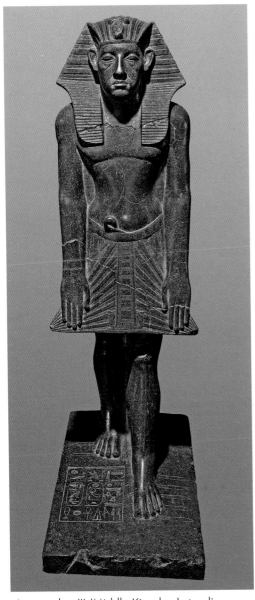

Amenemhat III (Middle Kingdom) standing with hands flat on his kilts in a gesture of prayer (Luxor Museum).

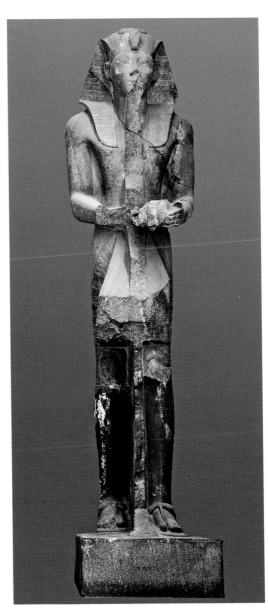

Colossal statue of Thutmose IV with outstretched arms (Egyptian Museum, Cairo).

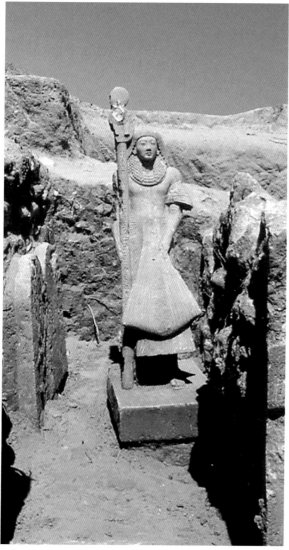

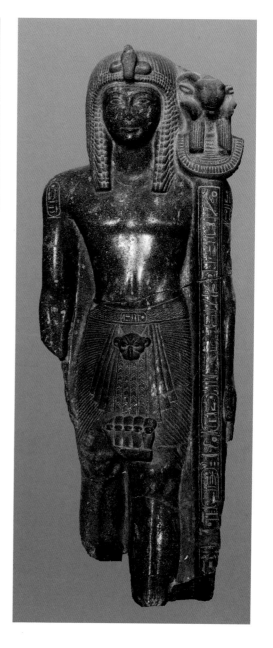

Above: statue of Commander Nebre holding a standard, from the fortress at Zawiyet Umm al-Rakham; right: statue of Ramesses III holding a standard (Grand Egyptian Museum).

By the Ramesside Period there was a new fashion for standard-bearer statues, where the king (or occasionally an elite male) was shown carrying one or two staves topped with a god's head or symbol. Such staves were carried during religious rituals, and these statues mimic actual events where the king acting as a priest (but still always a king) participated in a temple procession.

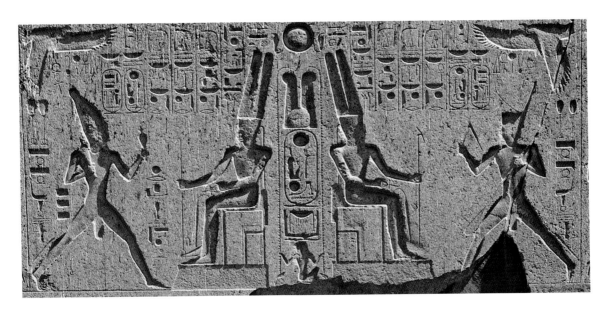

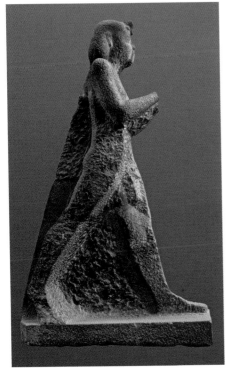

Relief on a lintel in Luxor Temple showing Ramesses II running toward the god Amun, and an unfinished figure of a striding king from the Third Intermediate Period (1069–664 BCE; Egyptian Museum, Cairo).

Striding Statues

This is an unusual variation, where the king was shown running, which may be an example of three-dimensional sculpture copying a form already well known from two-dimensional reliefs. It was a very active pose and probably indicated that the king was performing a particularly energetic ritual, perhaps during a royal jubilee festival called the Heb Sed. These rituals were supposed to be first celebrated by the king after thirty years on the throne, and then every three years afterward.

Standing Statues with Both Feet Together

Statues standing with their feet together were often used in an architectural context, either forming columns in their own right or placed between them. They sometimes had individually defined legs, but were more often in shrouded form as an 'Osiride' statue, representing Osiris or other mummiform deities (Ptah of Memphis, Min of Koptos, or Khonsu of Thebes). This is a

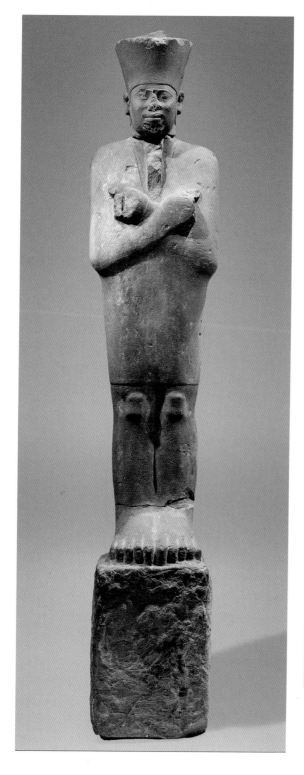

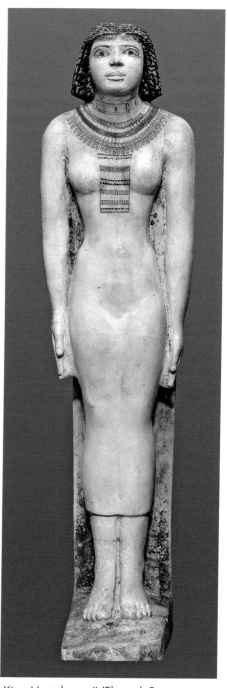

King Mentuhotep II (Eleventh Dynasty; Metropolitan Museum of Art, New York); and the Sixth Dynasty woman Satmerit (Egyptian Museum, Cairo).

static pose that suggested strength and stability, and it showed the king as receiver of ritual/offerings rather than giver. Single statues of elite women sometimes also show them standing with feet together.

Seated Statues

The person sitting down was always of a higher rank than someone standing or kneeling, and a seated king was a common subject for royal statuary from the Second Dynasty onward. He was often shown on a throne that was decorated with symbols of Upper and Lower Egypt. This meant that he was also representing the god Horus sitting on the lap of his mother the goddess Isis *(Iset)*, who was symbolized by a throne *(set)*. Many of these statues also showed the king wearing an ornamental bull's tail either between or beside his legs. This is a passive pose, with the king as receiver of offerings and prayers. There are also some seated statues of queens, either the wives or the mothers of ruling kings.

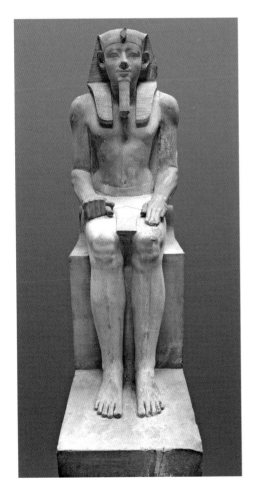
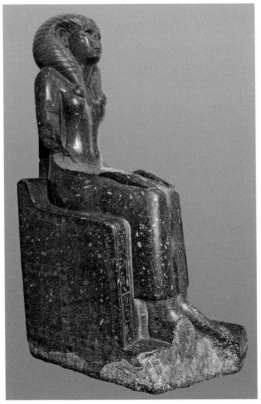

King Senwosret I on a throne (Middle Kingdom; Egyptian Museum, Cairo); and a seated statue of Queen Nofret, wife of Senwosret II (Middle Kingdom; Egyptian Museum, Cairo).

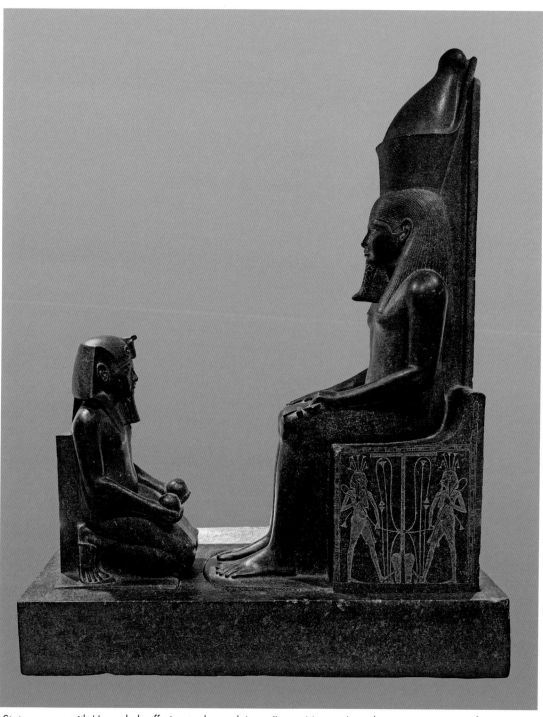

Statue group with Horemheb offering to the god Atum (Luxor Museum); and a prostrate statue of Ramessses II with an offering table (Egyptian Museum, Cairo).

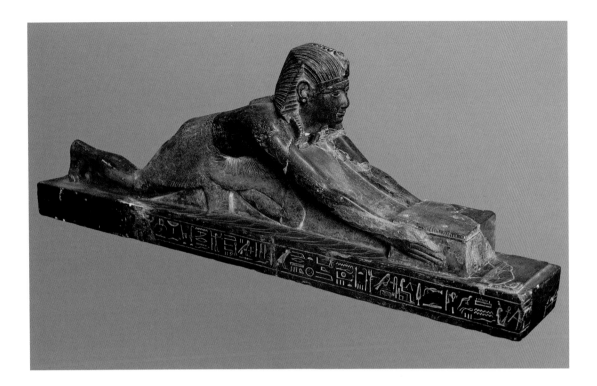

Kneeling Statues

Royal offering statues, already existing from the Old Kingdom onward, became popular during the New Kingdom. The pose indicated that the statue of the king was in front of a god and there are examples where a kneeling king offers pots containing wine, milk, or water to the gods as part of a ritual. In a less common variant of this, the king is shown in a more exaggerated pose, almost prostrate on the floor with one leg stretched out behind him and his chest leaning down toward the floor.

Others

Sphinxes were also common, with the king's head on a lion's body, symbolizing magical royal power. Rows of sphinxes showed the king as protector in front of temple entrances. From the New Kingdom onward there are also combined statues where a small figure of the king was protected by a sacred animal or animal-headed sphinx.

Group statues of the king and various gods are also known from the Old Kingdom onward. These were designed to show the king's special relationship with specific gods, often as their child. And from at least the Middle Kingdom onwards there are also a few examples where the king is shown twice; these may represent his dual nature as king of Upper and Lower Egypt or as a god and a man, or perhaps show the king and his soul *(ka)*.

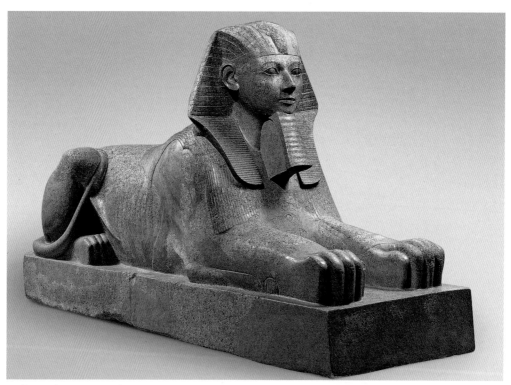

Sphinx of Queen Hatshepsut (New Kingdom; Metropolitan Museum of Art, New York).

Double statue of Amenemhat III as Nile gods (Middle Kingdom; Egyptian Museum, Cairo).

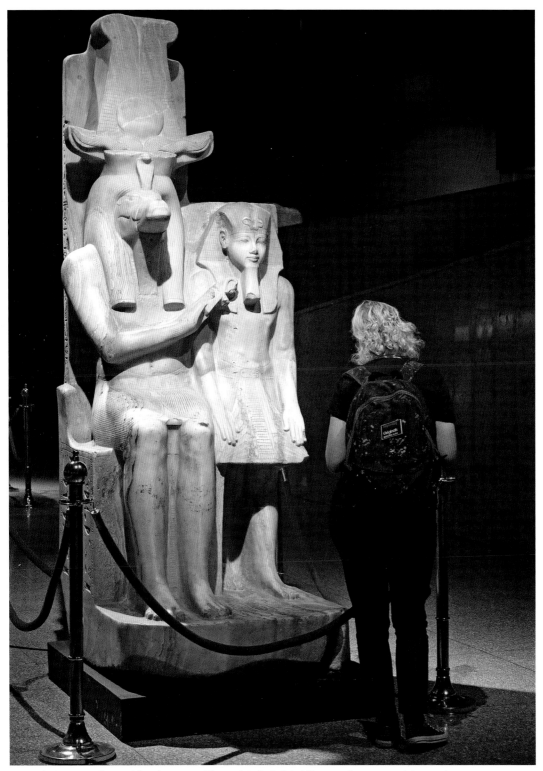

Amenhotep III embraced by the crocodile god Sobek (Middle Kingdom, Luxor Museum).

Scribe Statues and Block Statues

Elite men often showed themselves as scribes sitting cross-legged on the floor, often with a papyrus spread out on their lap. This did not mean that this was what they did for a living, but rather it was an indicator not only that they could read and write, but also that they were men of wisdom and learning. Kings were never shown in this pose, although there are examples of officials who later became kings being shown like this on their way to the throne.

Another popular form for men, but never kings, was the block statue. Elite men were shown seated on the floor with their legs up in front of them, often wrapped in a cloak or robe with only their head and hands defined in detail. It was an efficient way of using stone, and also created large surfaces suitable for decoration and inscription. First invented in the Middle Kingdom, by the Late Period thousands of block statues were deposited in temples all over Egypt. They were a mark of piety and allowed the *ka* (soul) of the worshiper to witness and benefit from religious rituals.

The production of large royal statues seems to have remained firmly under royal control. A stela dating from Year 8 of his reign describes how Ramesses II commissioned a

Vizier Horemheb as a scribe, before he became king (Metropolitan Museum of Art, New York).

Block statue of Iufaa (Twenty-second Dynasty; Egyptian Museum, Cairo).

number of statues and also indicates how long they might have taken to carve. The text on the stela described how, while walking in the desert south of Heliopolis, Ramesses "found a great quartzite rock, the like of which had not been found since the time of Re. It was longer than a granite obelisk." From this rock, "skilful men," were ordered to carve "a great statue of Ramesses, Meryamun the God." This task was achieved, and the statue emerged complete one year later.

The stela continues: "Now His Majesty found another quarry beside it for statues of quartzite, resembling red *meru* wood, and again he ordered them, this time for the Temple of Ptah. Names were given to them in the great name of His Majesty, namely Ramesses II Meryamun, Son of Ptah." After a long speech describing how well the king treated his workmen, the text concludes with descriptions of more quarries on Elephantine Island in Aswan,

which yielded "black granite for large statues, the double crowns of which are quartzite stone, and which is called the quarry of Ramesses Meryamun, the ruler of the Two Lands. I have found for you yet another quarry in the mountain, whose color is liked washed silver. It shall be called the Quarry of Ramesses Meryamun Loved by Ptah."

In order to carve a statue, the outlines of the front, sides, and back were drawn out on the four sides of a rectangular block. From at least the Middle Kingdom onward a drawing grid was first applied to the stone, which helped the stonemasons to line up all the sides correctly. Any spare material was then gradually chipped or carved away until a rough shape had been achieved. Hard granite was worked with even harder stone hammers (often basalt or dolorite) and sand as an abrasive, while softer limestone and sandstone could be shaped with flint, copper, and bronze drills and scrapers.

Statues were almost certainly not completed before they left the quarry, although the amount of in-situ working probably varied depending on the type of stone.

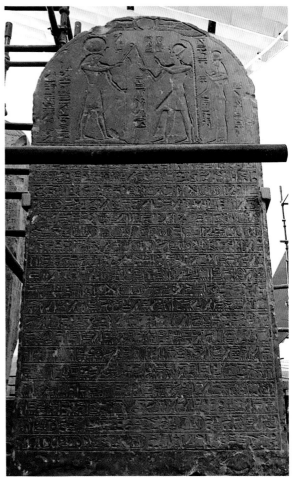

Large stela detailing how Ramesses II found stone suitable for statues (Grand Egyptian Museum).

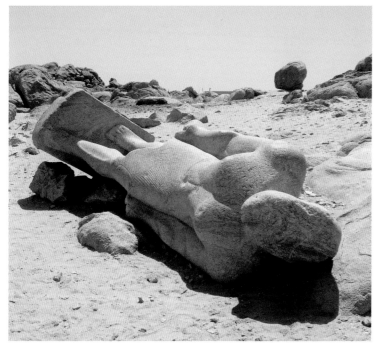

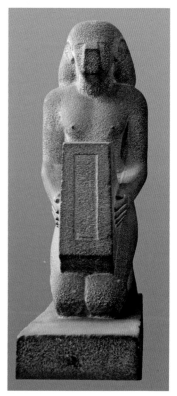

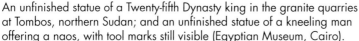
An unfinished statue of a Twenty-fifth Dynasty king in the granite quarries at Tombos, northern Sudan; and an unfinished statue of a kneeling man offering a naos, with tool marks still visible (Egyptian Museum, Cairo).

Remaining evidence of large objects left behind at quarry sites suggests that those carved from harder stones like granite were sometimes nearly finished before transportation, with perhaps only final polishing taking place at their destinations.

Softer stones that were more easily damaged, including limestone and sandstone, were probably transported as unfinished blocks that were then finely shaped, finished, and polished at or close to their final positions. Texts in the tomb of the Twelfth Dynasty governor Djehutyhotep describing the creation of a colossal statue say: "Behold, this statue, being a squared block on coming forth from the great mountain, was more valuable than anything."

Textual and pictorial evidence tells us that massive blocks of stone were pulled on sledges along specially constructed quarry roads to the riverbank, and then transported by boat to their destinations. Deliveries were probably timed to coincide with raised water levels during the annual flooding of the river, while canals leading to basins and harbors in front of many temples meant that the stones could be unloaded practically on-site.

Soft stone statues were smoothed, often plastered with gypsum plaster, and then painted. Both naturally occurring pigments and artificial paints were used, including

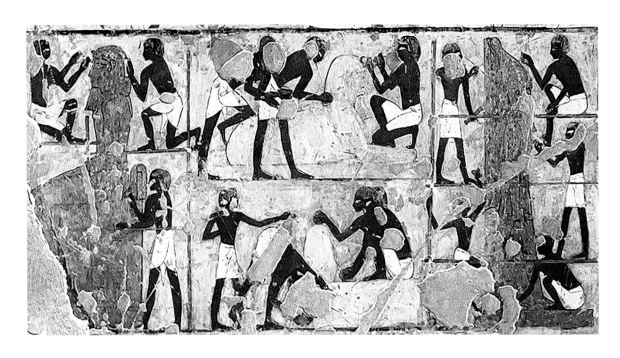

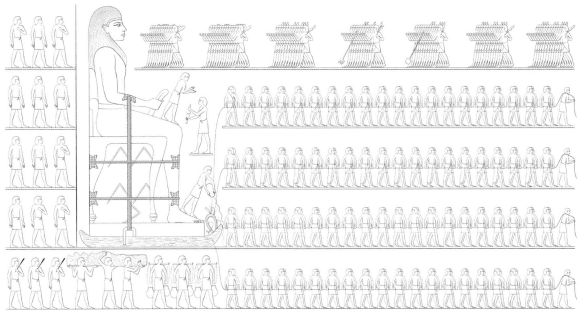

Above: scene from the tomb of New Kingdom vizier Rekhmire showing craftsmen finishing off two colossal statues and a sphinx of King Thutmose III—many of them are smoothing the statues' surfaces with round stones wrapped in leather or another material while other workmen are using paint brushes to decorate them; below: a scene from the tomb of Middle Kingdom governor Djehutyhotep showing a colossal statue being dragged from the travertine quarries at Hatnub in the Eastern Desert by more than sixty men (after Newberry 1894, pl XII).

carbon black, calcium carbonate white, red and yellow ochers, and blue and green artificial copper-based pigments (Egyptian Blue and Egyptian Green). During the New Kingdom, rare, brightly colored minerals that can fade or change color in daylight, including bright white huntite and bright yellow jarosite, were used to pick out details of special statues that were kept inside. Expensive gold leaf was also occasionally applied. Eyes were sometimes inlaid with rock crystal or black and white stones, and outlined with pigment, glass, or metal rims.

Hard stone statues also had certain details picked out in pigment and gold. These included crowns and headcloths, jewelry, and eyes, lips, and other facial features. For example studies of hundreds of black diorite Sekhmet statues from the mortuary cult temple of Amenhotep III on the west bank at Luxor show that they were originally painted with fiery red eyes.

Specific areas of hard stone sculptures were often roughened or left unpolished to make pigment and decoration easier to stick on with plant gum or animal glue, while other surfaces were burnished to a high sheen. There are also many examples where particular veins of color in hard stone have been exploited by the sculptor.

One of Sety I's great statues of black stone, with a crown from the Red Mountain, the mountain of quartzite, was cut from black granite with a vein of red granite running through it. The top half of a seated statue of Ramesses II known as the Young Memnon, originally from the Ramesseum and now in the British Museum, was also carved so that the statue's body is of black granite while its face and crown are from a vein of red granite running through the rock.

We do not know how many stonemasons *(sankhw)*, makers *(irw)*, or artists *(hmww)* were involved in the creation of statues. Nor do we know if a single supervisor was in charge of the whole process, or if different sculptors or groups worked on different stages of production, with some for carving, others for polishing, others for decorating, and so on. We also do not know if sculptors or teams of craftsmen always traveled from one site to another, or if the stones were brought to them. There is evidence for missions sent into Wadi Hammamat in the Eastern Desert, the Sinai Peninsula, and other areas to obtain *bekhen* (probably breccia or siltstone) and other stones for the manufacture of statues, and it seems likely that major temple sites would have had 'in-house' teams to deal with almost continuous construction, reconstruction, and decoration projects throughout the Ramesside Period, but as yet there is little real evidence for these.

Strict administrative control seems to have been kept over all stages of royal statue production. The missions to obtain stone were organized by government administrators and accompanied by military forces. Craftsmen worked from temple or royal city workshops. A complete workshop of the sculptor Thutmose found at Amarna included a

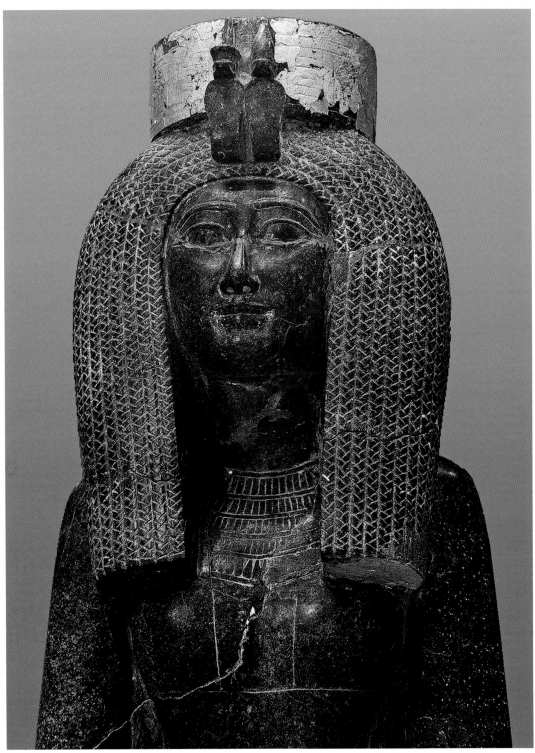

A black granite statue of Queen Iset, mother of Thutmose III, wearing a gilded crown with double uraeus snakes (New Kingdom; Egyptian Museum Cairo).

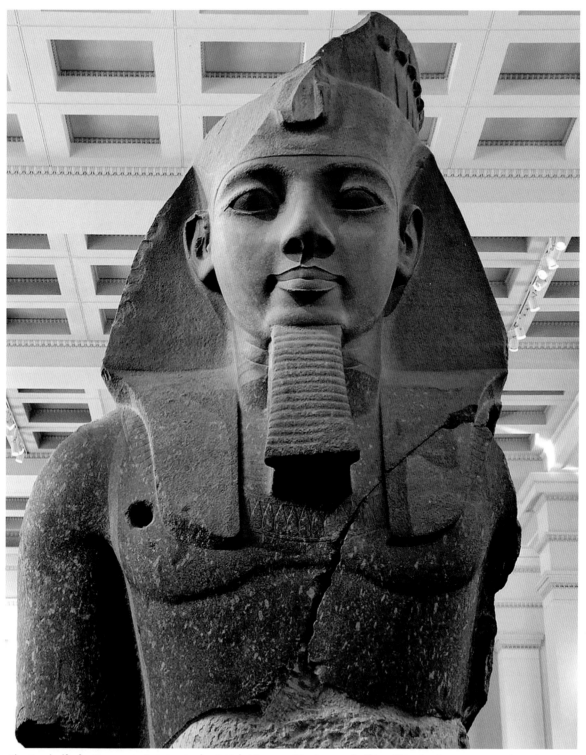

The top half of a Ramesses II statue in the British Museum (the bottom half is still in the Ramesseum at Luxor) carved from a single block of black and red granite.

showroom at the front and a studio full of plaster heads where potential clients could come and view models that could then be carved into stone. Subtle edits and changes to the heads, visible through modern scans, suggest that their appearance was carefully checked and monitored by official supervisors. There is also a scene in the Luxor tomb of Vizier Paser (TT106) where he is shown checking on the production of royal sphinxes and inspecting a King Sety I statue at a temple, saying "This statue of the lord you have made is very beautiful."

Different terms used by the Egyptians to describe statues have been identified by modern scholars. The word *twt*, derived from 'to resemble' or 'to be like' was used to label both two- and three-dimensional images. It is possible that this expression also meant to show the full nature or essence of a god or person, not just something that looked like them.

Another term used to describe cult images of gods and kings was *sšmw*. A stela dedicated by Tuthmose I describing building works at a temple to the god Osiris at Abydos mentions "*sšmw* images made for eternity."

The word *nfr*, meaning good, beautiful, or perfect, could also be used to describe images of gods, in the sense that they

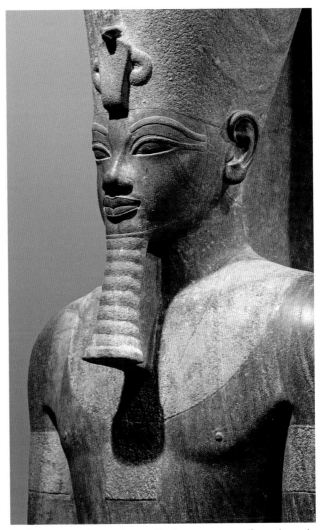

A fine statue of Amenhotep III, showing areas of roughened surfaces on his crown, broad collar, pectoral, and armlets where pigment or gold leaf was originally applied (New Kingdom; Luxor Museum).

were representing something perfect. A stela dedicated by Senwosret III's treasurer Ikhernofret, who was in charge of organizing an annual festival when a statue of Osiris traveled between his temple and his tomb at Abydos, records: "I made for him the boat shrine which displayed the perfection *(nfrw)* of the Foremost of the Westerners (Osiris)."

For Kings and Gods

Royal mortuary cult temples were built to serve the *ka* (soul) of each king after death, and maintain worship of their god-like aspect, as they had become one with the god Osiris. In the Early Dynastic Period these were small structures attached to tombs in burial sites at Abydos and Saqqara, often with huge enclosures built nearby. During the Old and Middle Kingdoms they were stone-built temples that formed an integral part of each pyramid complex. In the New Kingdom evolving beliefs meant that mortuary cult temples for dead kings together with gods (usually Amun-Re or Re-Horakhty) were large stone temple complexes built on the desert edge on the west bank at Thebes and Memphis.

Gods' temples were usually dedicated to a single deity, or perhaps a god and his holy family: mother, father, and child—the world of heaven was considered a similar but better version of Egypt, so divine society was arranged in a recognizable way with parents, siblings, and cousins. Many gods were also thought to come from a particular place or area, and their cult centers and worship often had a regional basis.

In Predynastic regional centers, early cult temples were constructed out of reeds, wood, and mud brick, of which few traces have remained in the archaeological record. During the Early Dynastic Period and the Old Kingdom, provincial cult centers dedicated to local gods continued to be built out of mud brick, and some also had a few stone features such as door thresholds and altars.

Growing royal interest in provincial cult temples during the Middle Kingdom (Eleventh to Thirteenth Dynasties, 2034–1650 BCE) was shown by an increased use of stone, a raw material extracted from quarries throughout Egypt under the control of the king. Evidence for these is rare, as most structures were demolished and rebuilt during New Kingdom temple expansions. The Middle Kingdom Twelfth Dynasty king Senwosret I (1956–1911 BCE) began a large-scale building program at important religious sites all over Egypt, from Elephantine in the south to the Delta in the north. Reconstructed examples include a fine limestone shrine from the Great Temple of Amun at Karnak that was later dismantled in the New Kingdom by the Eighteenth Dynasty king Amenhotep III during renovations, when the blocks were used to fill in his newly constructed pylon gateway (the third pylon). The Twelfth Dynasty king Amenemhat III (1831–1786 BCE) also had an ambitious building program, concentrating much of his work in the newly developing region of the Faiyum.

During the New Kingdom, massive temple-building programs became an important part of the king's responsibilities. Royal interest spread to sites throughout Egypt and its empire. Many existing temples were rebuilt from limestone that can still be found throughout the Nile Valley and desert plateau, and sandstone quarried from the Gebel al-Silsila quarries on the Nile in southern Egypt.

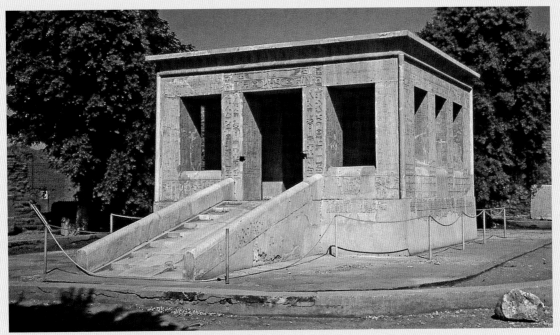

The White Chapel of Senwosret I, the stones of which had been used as filling for the third pylon, as reconstructed in the open-air museum in the Great Temple of Amun at Karnak.

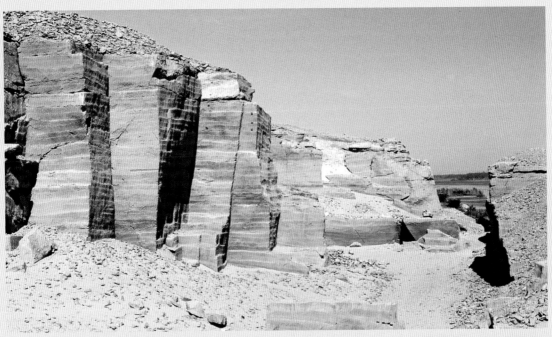

Sandstone quarries at Gebel al-Silsila.

A standard temple plan developed that was followed with little change up until the Greco-Roman period. This included pylon gateway(s), open courtyard(s), hypostyle hall(s), and sanctuary/ies surrounded by at least one enclosure wall.

The increased use of stone meant that temples could be decorated both inside and out. Almost all visible surfaces became covered with images of kings and gods performing various actions. Different types of scenes were produced to be viewed by different audiences. Reliefs that most people could see on outside walls and pylon gateways showed the king (and only the king) the same size as gods. Actions included defeating Egypt's enemies, while a protective god in the form of a bird hovered above his head, and making offerings to the gods. Inside the temple the king was shown in two and three dimensions offering to the gods, performing sacred

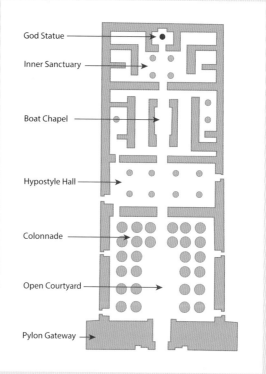

A good example of a typical temple layout, the temple for the god Khonsu built by Ramesses III at Thebes contained standard features including a pylon gateway, open courtyard, hypostyle hall, and sanctuaries.

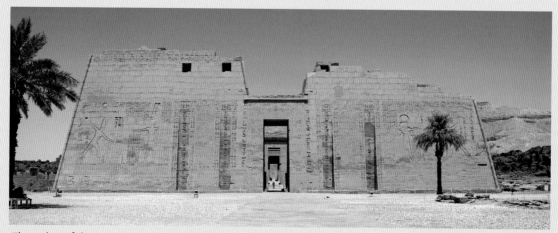

The pylon of the mortuary cult temple of Ramesses III at Medinet Habu, showing Ramesses III smiting prisoners in front of the gods Amun-Re (left) and Re-Horakhty (right).

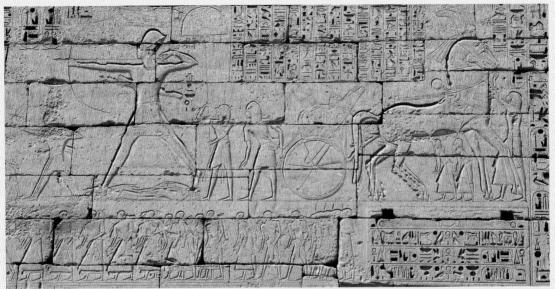

The outer walls of Medinet Habu show Ramesses III in battle with the Sea Peoples, with archers, a fan-bearer, and a waiting chariot, as he shoots on foot, with attendants and soldiers below the scene.

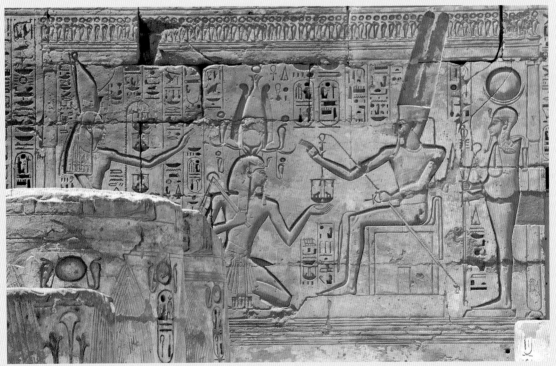

In the inner hypostyle hall of Medinet Habu, the goddess Mut stands behind a kneeling figure of Ramesses III, who is being given the jubilee symbol by the god Amun-Re, whose son Khonsu stands behind him.

rituals, and officiating at state festivals. In the most hidden areas of temples, the king was portrayed as offering to and receiving gifts from the gods, even when these scenes were hidden from almost everyone and were for the benefit of the gods alone.

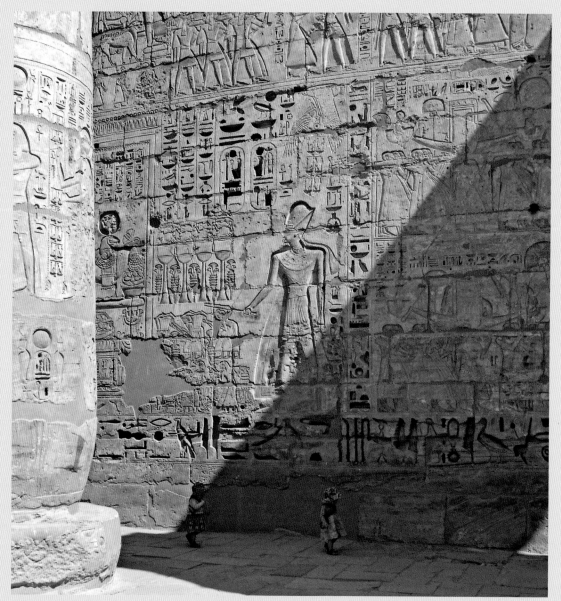

In the second court of Medinet Habu, Ramesses III blesses offerings that are being made by rows of priests in front of the sacred boats of the god Amun-Re, goddess Mut, and their son Khonsu.

3 Royal Statue Cults

During the reign of Ramesses II, a series of cults grew up around some individually named statues of the king: non-elite worshipers visited the statues, prayed to them, and left offerings. This was not a new practice, but was the development of blurred boundaries between the divinity of the god, the king, and the statue.

The reign of Amenhotep III, in the Eighteenth Dynasty, had been characterized by a growing emphasis on the cult of the king, and this was supported by the creation of at least one thousand large statues of Amenhotep as king, Amenhotep with the gods, and perhaps even Amenhotep as a god. These tended to have recognizable features, with obliquely-set almond eyes, a rounded, fleshy face, a broad-based, slightly snubbed nose, and a sensual mouth with an incised lip line. The king was always shown as a young man, whenever the statue was carved throughout his near-forty-year reign. The importance of identifiable features was demonstrated by the fact that when Ramesses II renamed some of these statues, he not only added his own cartouches but also changed the appearance of their faces.

There was also a cult of Amenhotep III in Nubia, where large royal statues and depictions of the living king as a god were placed in temples for propaganda purposes. Egyptian control over Nubia was re-established at the beginning of the New Kingdom as a foreign policy priority of early Eighteenth Dynasty kings, and was consolidated by an administrative structure that removed most significant political or economic activity from the Nubians themselves. Amenhotep III constructed a temple at Soleb dedicated to the cult of himself as Nebmaatre, Lord of Nubia (referring to the king by his throne name).

The most famous statues of Amenhotep III are the so-called 'Colossi of Memnon' that flanked the entrance to his mortuary cult temple. Inscriptions on their backs show that both were once named Nebmaatre Ruler of Rulers. A stela of unknown provenance

51

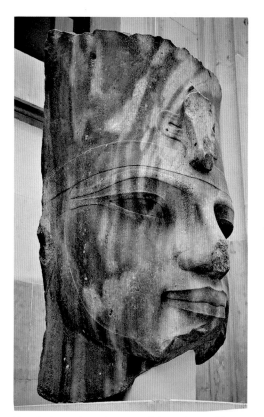

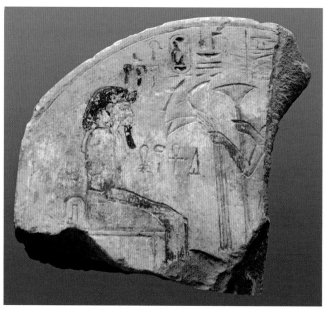

A stela showing a worshiper offering flowers to a seated statue of Amenhotep III named Nebmaatre Ruler of Rulers (Art and History Museum, Brussels; photograph by C. Price).

Head of a colossal statue of Amenhotep III, with recognizable features including eyebrows in relief, obliquely-set almond eyes, rounded, fleshy face, snubbed nose, and a mouth with an incised lip line (British Museum).

The 'Colossi of Memnon,' both named Nebmaatre Ruler of Rulers (photograph by A. Jiménez-Higueras).

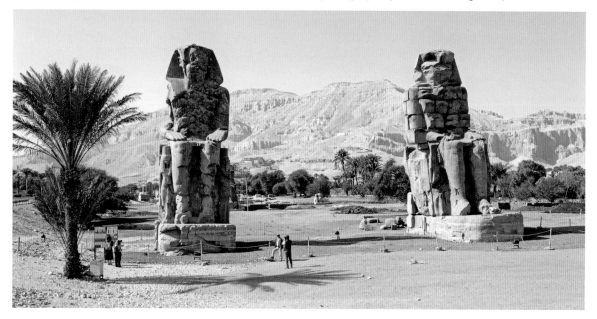

shows a worshiper offering a bunch of flowers to a seated statue of Amenhotep III with this name, and a graffito at Aswan shows the chief sculptor Men making offerings to a statue of Amenhotep III also called Nebmaatre Ruler of Rulers.

These named statues and the stelae showing worshipers commemorating them suggest a subtle shift in practice, where the royal statue was no longer just a vessel containing the soul *(ka)* of the king that would pass on the hopes and prayers of worshipers to the god, but had become a vessel for the living king himself as an object of worship. In some respects, this paved the way for religious innovations during the reign of Amenhotep III's son and successor, known to modern scholars as the Amarna Period.

The new theology invented by Amenhotep IV involved ignoring and sometimes repressing most gods other than the Aten, his favorite aspect of the solar deity, and also changing the way that the king himself was both projected and perceived. By Year 5 of his reign he had changed his name to Akhenaten and begun construction of a new religious capital city at Amarna in Middle Egypt.

The Aten sun disc appears to have had no personality, and, after the first few years of the reign, no anthropomorphic manifestation associated with it in a form that the Egyptians would have recognized, and neither was it part of any family or group of gods. During

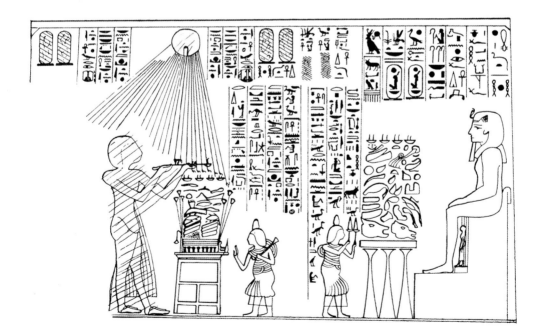

Chief sculptors Bak (left) and his father Men, who is offering two incense cones to a seated statue of King Amenhotep III named Nebmaatre Ruler of Rulers, perhaps one of the Colossi of Memnon (after Habachi, 1965).

the Amarna Period the Aten was promoted as the actual father of Akhenaten, who had become the physical embodiment of the god on earth. This also meant that Akhenaten was the only person who heard and understood the teachings of the Aten. Whereas previously people indirectly adored the king by worshiping local and national gods, the power assumed by Akhenaten meant that the god could only be worshiped through him.

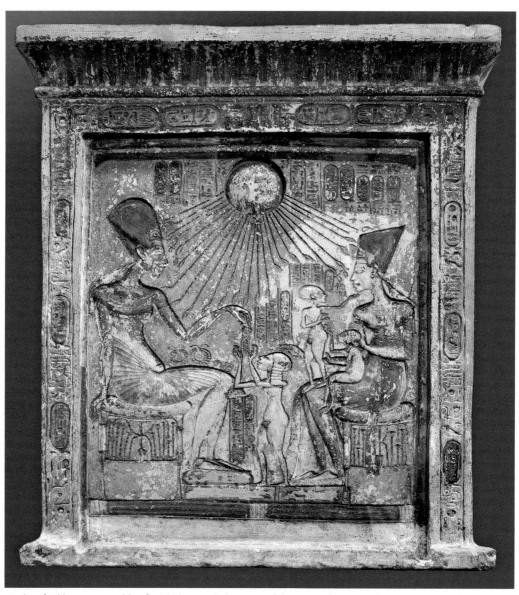

Stela of Akhenaten and his family beneath the rays of the Aten, from an altar in a private house at Amarna (Egyptian Museum, Cairo).

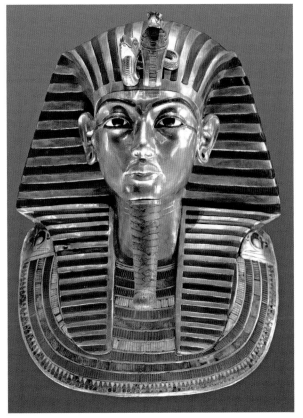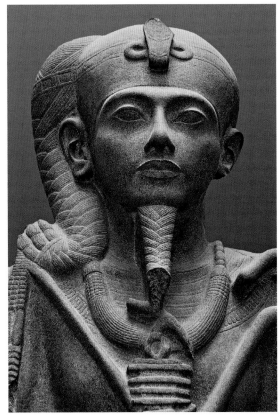

Tutankhamun's golden burial mask; and a statue of the god Khonsu with Tutankhamun's face, which was carved during his reign (Egyptian Museum, Cairo).

The new religion also required its own priesthood. Previously the priests (as substitutes for the king) were channels through whom the people were able to reach the gods, but under Akhenaten they seem to have acted as servants only to the king. After the death of Akhenaten and the end of the Amarna Period, kings quickly abandoned his concept of a single deity. However, certain aspects of the god-like nature of the king and his special relationship to the gods seem to have continued.

Kings Tutankhamun and Horemheb ordered craftsmen, including Chief Sculptor of the Lord of the Two Lands Hatiay and Overseer of Works and Superintendent of Craftsmen Dedia, to replace many precious statues of gods and goddesses destroyed during the Amarna Period, giving them the facial features of the king or his wife. Indeed, for most of ancient Egyptian history, kings were almost certainly the only people allowed to commission new statues of the gods, and it is noticeable that many of these statues have similar faces to the kings that ordered them.

Ramesses II Statue Cults

Ramesses II took over statues of earlier kings, erasing their names and carving his in their place, and in some cases recarving the faces to match more closely with his own approved image. He also took over unfinished statues commissioned by his father and named them for himself, as well as ordering many, many new statues.

Renaming royal objects did not necessarily mean that the king was trying to wipe out or destroy the memory of the previous ruler. Ramesses sometimes renamed inscriptions and statues created by his own father and grandfather, especially during the latter part of his reign. This was in order to promote himself and his own power rather than as dismissal or punishment of his predecessors, and such forms of reuse may even have been seen as a respectful gesture towards his ancestors.

Four colossal seated statues at Luxor Temple were commissioned by Sety I but left unfinished by the time of his death, and these were inscribed by Ramesses for himself: two still flank the earlier processional colonnade built during the reign of Amenhotep III, while two more are in front of the first pylon.

Many other colossal statues of the king were soon standing in towns and cities throughout Egypt and Nubia. At least fifty were commissioned just for the new capital at Piramesse. Though little of it can be seen today, the city of Piramesse (House of Ramesses), near the old Hyksos capital of Avaris in the northeast Delta, was famous throughout Egypt and beyond for the beauty of its new buildings and gardens. It contained large temples, palaces, luxury villas, administrative offices, army barracks, workshops, and quarters full of foreign merchants.

The vast majority of buildings and artifacts from this site were removed and usurped by later rulers, to the extent that the actual location of the city was a subject of great debate until the 1960s, when excavations at the neighboring sites of Tell al-Daba and Qantir identified the locations of both Avaris and Piramesse.

At Memphis there is evidence for up to twenty massive statues of Ramesses standing in and around the Great Temple of Ptah. In Nubia, new temples included many large statues of the king. The Great Temple of Abu Simbel is the largest and most impressive of these. The façade is fronted by four huge seated colossal statues of Ramesses, each approximately 20 meters high, while the entrance opens into a great hall that contains two rows of four engaged Osiride statues of the king. The smaller temple at Abu Simbel is fronted by statues of Ramesses and his wife Nefertari, and there are a few other examples of colossal Ramesside women, including his daughter/wife Meritamun found at Akhmim (although the statue was probably taken over from an Eighteenth Dynasty queen) and another unnamed wife and/or daughter found at Bubastis.

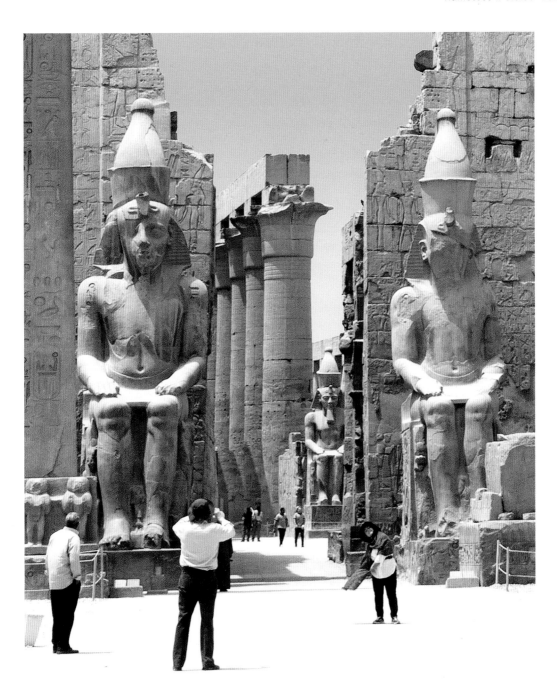

Two seated statues in front of the Luxor Temple pylon, originally commissioned by Sety I but later inscribed by his son Ramesses II for himself; a third statue in front of the processional colonnade is visible in the background.

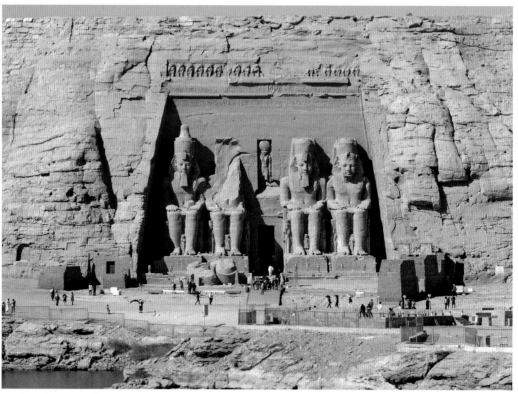

Colossal statues of Ramesses on the façade of the Great Temple of Abu Simbel.

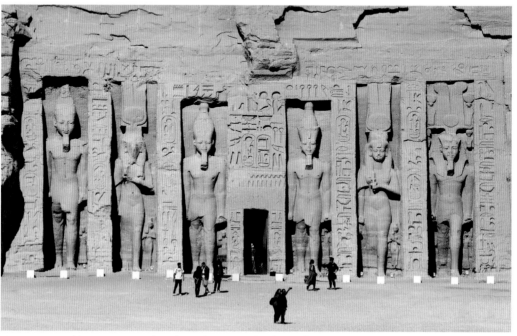

Ramesses and his Great Royal Wife Nefertari on the front of the Smaller Temple of Abu Simbel.

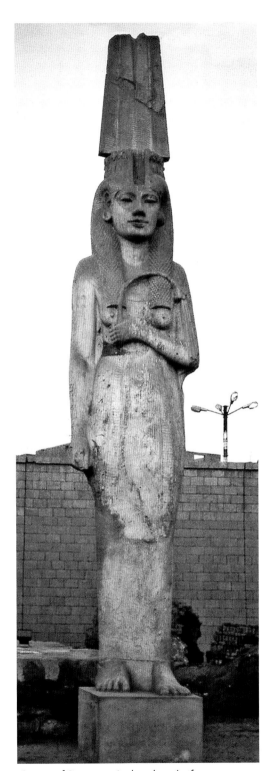

Statue of Ramesses's daughter/wife
Meritamun found at Akhmim.

Statue of an unnamed daughter of Ramesses
found at Bubastis.

At Thebes, the Karnak temple complex was dotted with huge new statues of the king. His mortuary cult temple on the west bank, now known as the Ramesseum, also contained many statues, including the largest freestanding statue ever known from Egypt, with an estimated weight of 1,000 tons, which still lies in ruins at the site.

The first court of Luxor Temple contains eleven statues of Ramesses standing between the rows of columns (some almost certainly reworked from statues of Amenhotep III), while four more originally stood in front of the first pylon next to the seated statues. Pieces of all four have been found at the site, and all have been gradually reconstructed by Egyptian antiquites authorities.

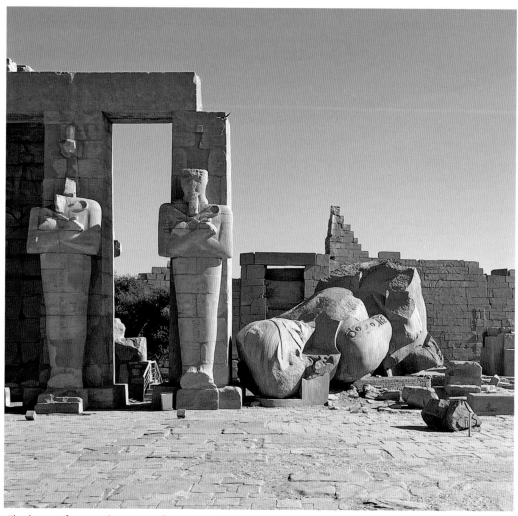

The largest freestanding statue from ancient Egypt, lying in ruins at the Ramesseum, the mortuary cult temple of Ramesses II on the west bank at Thebes.

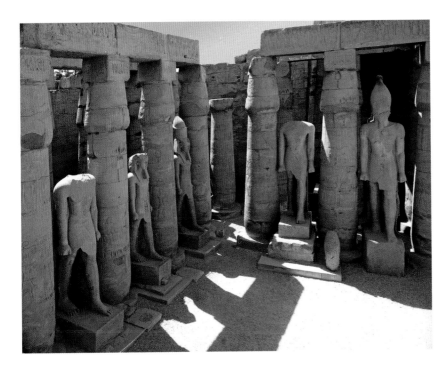

Five of eleven standing statues of Ramesses II between the columns of the first court of Luxor Temple.

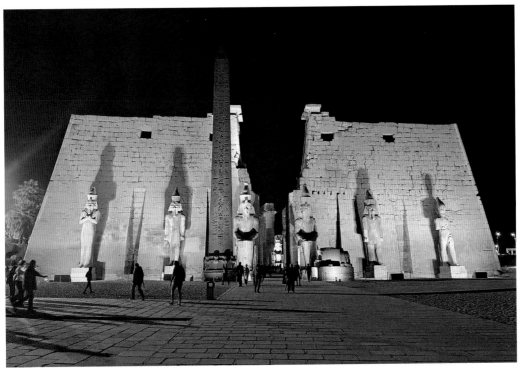

Standing and seated statues of Ramesses II in front of the first pylon of Luxor Temple.

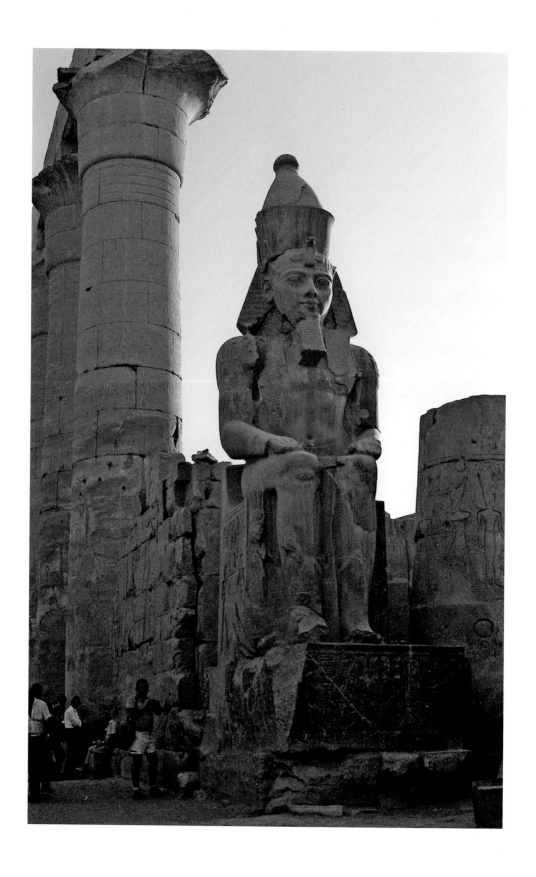

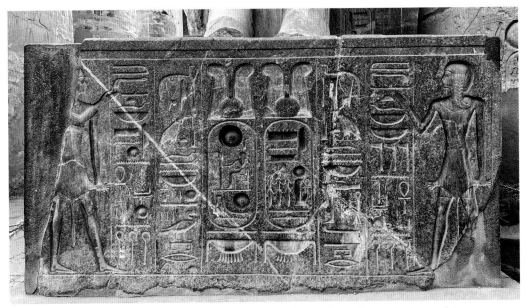

Opposite: The seated statue of Ramesses II named Re of the Rulers; above: the base of the same statue shows princes dressed as priests worshiping in front of an inscription that says: "The living royal *ka*, Re of the Rulers."

One of the seated statues, to the west of the colonnade entrance, was engraved with its own name. It is called Usermaatre Setepenre, Re of the Rulers on the left shoulder and Ramesses Meryamun, Re of the Rulers on the right, with the name Usermaatre Setepenre, Re of the Rulers repeated on both the throne and the rear pillar. An inscription on the base of the same statue shows princes dressed as priests worshiping in front of an inscription that says: "The living royal *ka*, Re of the Rulers."

This is probably the first example of Ramesses II inscribing colossal statues of himself with their own names. Others were called The God, Ruler of Rulers, Montu in the Two Lands, Loved by Atum, and Loved by Ptah.

Many of these statues soon became focuses of their own cults, with their own priesthoods and temple singers and musicians, including Isis, Chantress of Montu in the Two Lands and Kaemwia, Lady Musician of Montu in the Two Lands. There is also evidence of small chapels set up for worshipers near some of the statues, where stelae were dedicated by people often with military titles such as Scribe of the Army of the Lord of Two Lands, and Standard Bearer of the Lord of Two Lands of the Regiment of Re of the Rulers, showing them making offerings to differently named statues. Other titles on stelae from Piramesse show that the worshipers included people who worked in the royal palace, with examples of fanbearers, a lady of the house, washermen, and servants.

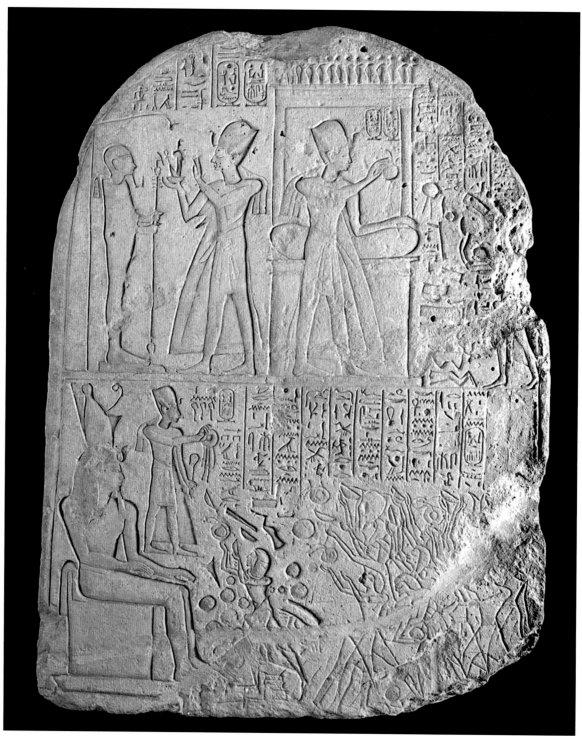

A stela of a scribe of the army called Mose, who is receiving gifts from Ramesses II (above) and standing as part of a crowd (below) being offered rewards from Ramesses II next to a seated statue named Ramesses Meryamun Re of the Rulers (Roemer- und Pelizaeus-Museum Hildesheim).

A small industry seems to have grown up around the statue cults. Along with the dedicated priesthood and supporting staff, there were also production sites for memorabilia including the stelae and scarabs inscribed with the names of statues. Large numbers of scarabs and their molds found at Piramesse suggest that these were mass-produced in a factory site, probably attached to a temple or a royal palace. This also suggests that substantial numbers of pilgrims may have gathered to participate in specific festivals or ceremonies for these statues.

As is often the case with the long-distant past, it is very difficult to determine the extent to which such cults were a spontaneous reaction of the pious, or whether popular interaction with large, named statues associated with temples was officially planned as a way for the general population to access an aspect of the living king. Perhaps it was a combination of the two, where an observed phenomenon became officially codified through Ramesses supplying and naming statues of himself in areas where they could be accessed by worshipers. There was certainly official supervision of the cult practice. One of the many job titles of Vizier Paser, already seen inspecting the production of royal statues, was as one "who adorns the king in his sacred image."

Interestingly, the king himself is sometimes shown in stelae dedicated by the faithful to be making offerings to statues of himself in exactly the same way that he is shown behaving in front of statues of other gods. It is also hard to tell the extent to which the average Egyptian believed they were worshiping an abstract king or concept, or if they were simply worshiping the statue.

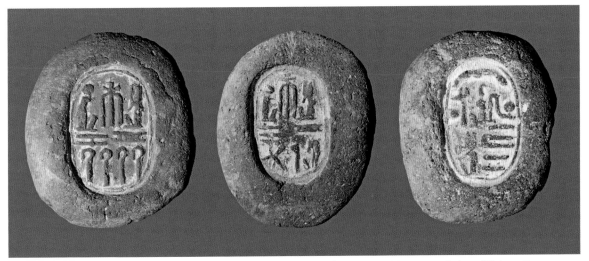

Scarab molds from a factory site at Piramesse for statues named Ramesses Meryamun Ruler of Rulers, Ramesses Meryamun the God, and Usermaatre Setepenre Montu in the Two Lands (Grand Egyptian Museum).

The same name could be used for more than one cult statue. In the Ramesseum, the enormous red granite colossus has the same name as the seated statue in Luxor temple, with Ramesses Meryamun, Re of the Rulers inscribed on its left shoulder and the pedestal and Usermaatre Setepenre, Re of the Rulers on the right shoulder.

A contemporary text called *In Praise of the Delta Residence* from the new capital city Piramesse lists a number of new statues, including one named Re of the Rulers as Vizier. Although the site has been heavily robbed of almost all its stone, it is possible that parts of this colossus were later moved to the sites of Tanis and Bubastis in the Delta. At Tanis, large pink granite fragments including the inscription "Usermaatre Setepenre, Re of the Rulers" were built into a later gate of Sheshonq III (825–773 BCE), and a large pink granite headdress found at Bubastis spells out the name Ramesses, Meryamun, Re of the Rulers, consisting of a large sun disc *(Re)* with a small child *(mes)* and the god Amun crouching in front of it, with a large 'loved by' *(mer)* sign carved underneath, giving the name Ramesses Meryamun; the figures sit between three 'ruler' *(heqa)* signs, and 'of' *(n)* is also carved on the base, giving 'Re of the Rulers'. This epithet is also carved in hieroglyphs on the side.

Such rebus statues were designed with wordplay and puns in mind, and consisted of individual components and three-dimensional hieroglyphic signs used together to make up a name or title. These visual motifs demonstrated both sophistication in the use of statuary and also the practical nature of Egyptian art. The technique was much favored by Ramesses II, and a number of statues spell out aspects of his name.

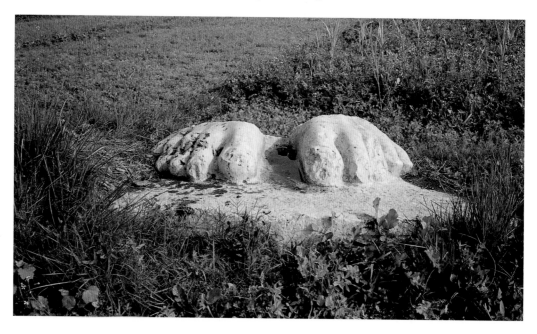

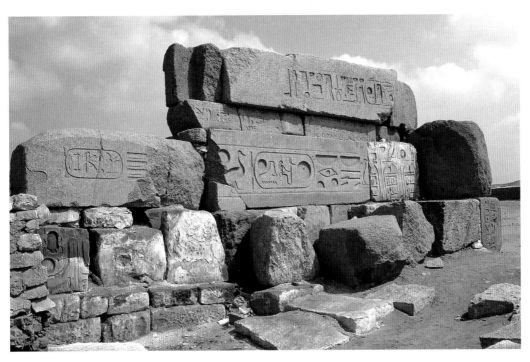

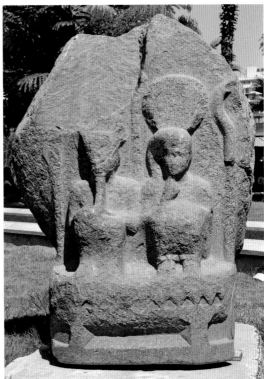

Opposite: the feet of a colossal statue at Piramesse (© Qantir-Piramesse-Project, Axel Krause); above: fragments from a statue named Usermaatre Setepenre Re of the Rulers built into a gateway at Tanis; right: a granite headdress in the form of a rebus spelling Ramesses Meryamun, from a statue found at Bubastis (Egyptian Museum, Cairo).

4 Memphis and the Temple of Ptah

I t is difficult to recreate an accurate map of Ramesside Memphis today. Too little of the site has been excavated and recorded in modern times, and much of the ancient city remains buried under modern settlement and agriculture.

Manetho (around 300 BCE) was an Egyptian priest and historian who could read both Egyptian and Greek texts. Probably using temple libraries, king lists, literary texts, and other sources, he wrote a detailed history of Egypt called *Aegyptiaca*. This divided kings into thirty dynasties, a system still followed by historians today. Unfortunately, the complete book has not survived, but excerpts and chapters are known from the works of later writers.

Manetho said that Memphis, the first capital of Egypt, was founded by "Menes" (probably King Narmer or King Aha) when the country was unified at the beginning of the Dynastic Period in around 3100 BCE. Located at the junction of the Nile Valley and the Delta, Memphis was designed to maintain the union between the two lands *(tawy)* of Upper and Lower Egypt. As the administrative capital and center of kingship, the city flourished and grew throughout Egyptian history.

The exact location of Early Dynastic and Old Kingdom Memphis is unclear, lost somewhere beneath meters of silt built up over thousands of years of Nile floods. It can be guessed at being somewhere to the northwest of later monuments, and core samples suggests that it lay close to the desert edge, below the hill where the earliest tombs from the Saqqara necropolis have been found.

From the early Old Kingdom onward the city was called White Walls *(Ineb Hedj)*. The name may come from the appearance of a whitewashed fortified palace somewhere at the site. Another suggestion is that the earliest part of Memphis was located on the western side of the valley against the edge of the pale stone cliff that rises up to form the Saqqara plateau. Toward the end of the Old Kingdom, in the Sixth Dynasty, Pepy I

69

(2321–2287 BCE) built his pyramid complex at the south end of the Saqqara plateau facing the city. This was named The Lasting Beauty of Pepy *(Men Nefer Pepi)*. The cult of King Pepy lasted for centuries, and the name Men Nefer gradually became used for the whole city of Memphis, probably leading to the modern name. During the Middle Kingdom the center of the city probably lay directly to the east of this pyramid.

An as-yet undiscovered area of royal memorial temples, probably between settlements to the east and cemeteries to the west, and dating from the Middle Kingdom onward, was called Life of the Two Lands *(Ankh Tawy)*, and this became used as the general name for the Memphis region.

By early in the New Kingdom, Memphis was the administrative capital of Egypt and an exciting, bustling cosmopolitan city, dominated by enormous temple complexes dedicated to the god Ptah. Although much archaeological evidence remains buried under modern development, contemporary documents and comparisons with other sites show that the city was also an important military base and international trading center, with ships trading around the Eastern Mediterranean able to sail south through the Delta along a Nile branch to the city docks called Bon Voyage *(Perunefer)*.

The original Old Kingdom settlement may still have been visible in the north, while a gradual shift eastward of the Nile had allowed more land to be reclaimed, creating space for the later New Kingdom city. This included leafy suburbs of large villas surrounded by smaller houses that grew up around a series of new royal palaces first started by Thutmose I (1504–1492 BCE), built along the banks of the Nile. Amenhotep III (1390–1352 BCE) created a new Great Temple of Ptah on new land to the southeast of the Old Kingdom temple and settlement, and foreign peoples with their own gods and customs were also settled in different areas of the city.

The Nile continued to shift eastward across the valley and by the end of the Eighteenth Dynasty the old city docks were probably silted up and abandoned. New areas of fresh land left behind by the movement of the river became available, and these were developed during the Nineteenth Dynasty.

Memphis in the Ramesside Period

Ramesside Memphis was a splendid city. Sety I commissioned new hypostyle halls for both Amun in Thebes and Ptah in Memphis. Both were continued by Ramesses II, who renamed them Glorious is Ramesses II in the Domain of Amun/Ptah. Ramesses also added a new Jubilee Hall in Memphis, with columns and a pylon gateway, called the West Hall of the Temple of Ptah. This building faced westward, looking toward the pyramids and tombs on the Saqqara plateau.

Ptah and Other Gods

Ptah was one of the oldest Egyptian gods, known from at least the First Dynasty (3000 BCE) onward. His first title was Lord of Memphis, and later he also became Ptah Who Is South of His Wall, referring to a sanctuary south of the original walled city, and Ptah Who Is Under His Moringa Tree, referring to a sacred tree that was cultivated for its leaves, pods, and seeds.

Ptah had a number of characteristics and special areas of interest. As a creator god he was said to have made the world from his thoughts and words. Connected to this, he was also thought of as the patron god of artists and craftspeople, and the high priest of Ptah at Memphis was known as Greatest of the Controllers of the Craftsmen of Ptah.

The Greeks later associated him with Hephaestus, their god of fire, metalworking, and sculpture, while the Romans saw him as Vulcan, also a god of fire and craftsmen.

Ptah was also a god who heard prayers, and one of his titles was The Ear that Hears. Many stelae found in his Great Temple in Memphis were decorated with one or more listening ears.

Ptah was always shown in human form, wrapped in a tight garment that looked like mummy bandages, and was either shaven-headed or wearing a blue fitted cap. While other gods had long beards that curl outward at the end, Ptah had a long, straight, squared-off beard. He often wore a necklace consisting of many strands of beads, with a heavy, keyhole-shaped counterpoise (menat) hanging

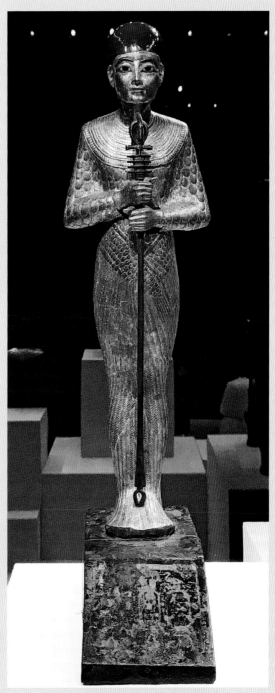

The god Ptah, from the tomb of Tutankhamun (Hurghada Museum).

down his back. Similar necklaces were carried by women during religious ceremonies, when they were shaken to create a soothing noise thought to appease a god or goddess. Figures of Ptah often hold a scepter topped with a 'power' *(was)* sign, or with was, 'life' *(ankh)*, and 'stability' *(djed)* symbols. He is usually shown either standing, sitting on a throne, or in a small shrine.

His holy family included his wife Sekhmet and his son Nefertem. Sekhmet was a feline goddess usually shown as a lioness-headed woman. She was simultaneously a fierce fighter who breathed fire on the king's enemies, and a healing goddess who protected the king. Nefertem was god of the first lotus blossom that rose from the waters of creation, and also, more generally, the god of perfumes. He was often shown as a young man with a lotus blossom on his head, or sometimes as a boy coming out of or sitting on a lotus flower.

One of Ptah's symbols on earth was the Apis bull, which lived in his temple-precinct at Memphis. Identified by distinctive markings, the bull would be replaced on its death by a calf bearing the same markings. From the late Eighteenth Dynasty, each bull was buried at Saqqara.

Ptah was often linked with other gods who were also seen as creators. He had a very close connection with another Memphite god named Tatenen, and from the Ramesside period onward was sometimes shown as a combined Ptah-Tatenen figure. Known from at least the Middle Kingdom onward,

A stela of Ptah with listening ears, from the Great Temple of Ptah at Memphis (Grand Egyptian Museum).

Tatenen ('risen land') represented the first mound emerging from the waters of creation. Tatenen was usually shown as a bearded man with a headdress made of a sun disc with rams' horns and two plumes.

Another ancient god from the same region was the falcon god Sokar, who was the patron deity of the Memphite necropolis stretching from Giza to Dahshur. By the Middle Kingdom, Sokar was linked with Ptah and the other underworld god Osiris, to form a triple funerary deity called Ptah-Sokar-Osiris, who remained popular up until the Roman Period.

Ramesses described his improvements at Memphis in a document called *The Blessing of Ptah*, copies of which were carved onto a number of temples in Egypt and Nubia. "I enlarged your Temple in Memphis, constructed in eternal work, excellently crafted, in stone, finished off with gold and real precious stones. I laid out your esplanade on

Above: remains of a colossal statue at the western pylon of the Great Temple of Ptah at Memphis; below: masonry of the western hall (photographs by B. Ezzat).

the north, with two noble walls/halls (?), opposite you, their doors like the horizon of heaven, causing the ordinary folk to adore you."

The Blessing also refers to a different building that was probably another memorial temple for the king's *ka* after death, somewhere to the west of the new Ptah temple and perhaps mirroring the king's mortuary cult temple being constructed on the west bank at Thebes, now known as the Ramesseum. "I make for you a noble temple within Memphis, divine is your image in the mysterious shrine, sitting on its mighty seat."

The Ptah temple complex, surrounded by high enclosure walls with monumental entrance gateways, was called House of the Soul of Ptah *(hut ka Ptah)*. It included the

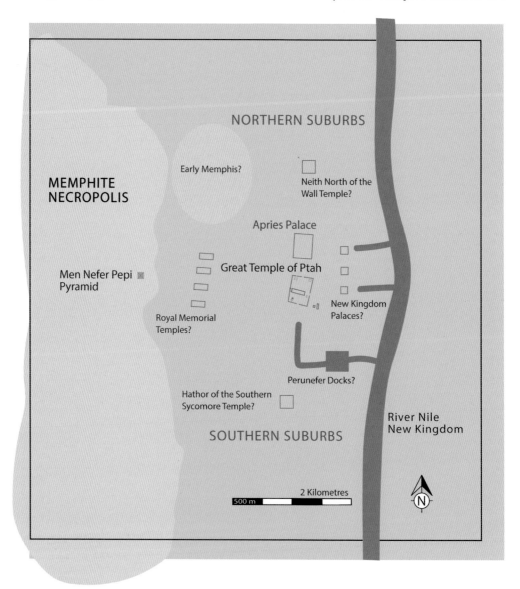

Great Temple along with smaller buildings dedicated to the cults of related gods, including a hybrid form of himself called Ptah-Tatenen (another creator god), Ptah-Sokar (a falcon god from Memphis), and Hathor of the Southern Sycomore and Neith North of the Wall. There were also substantial perimeter walls, gateways, and processional routes linking separate areas of the site.

Smaller temples built to celebrate one or more of the king's jubilee festivals lay south and west of the main precinct, including one dedicated to Ptah, with a pylon gateway and triple shrines, and another dedicated to the goddess Hathor.

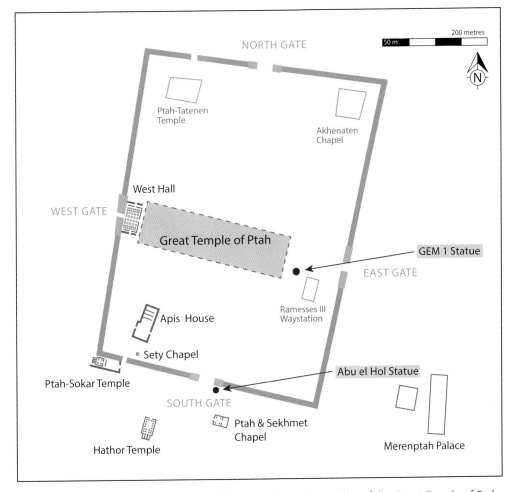

Opposite: suggested map of New Kingdom Memphis; above: plan of the Great Temple of Ptah. The exact location of only a few sites is known, but there is enough historical and archaeological evidence to help estimate the areas of other buildings and districts. The main Ptah temple complex was surrounded by high enclosure walls with monumental entrance gateways. It contained the Great Temple, along with smaller buildings dedicated to the cults of related gods. Other ceremonial buildings were sited along ritual paths leading out of and around the complex.

Above: chapel of Sety I; below: Temple of Ramesses II; opposite above: Chapel of Ramesses II; opposite below: small Hathor temple (all south of the main Ptah temple complex at Memphis).

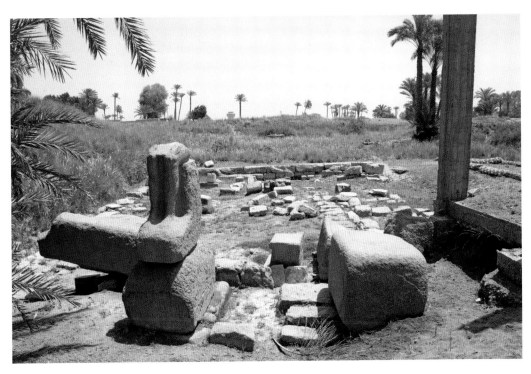

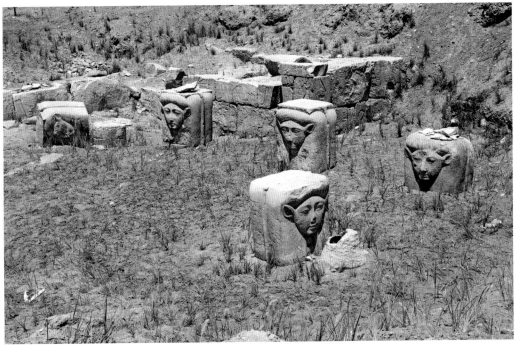

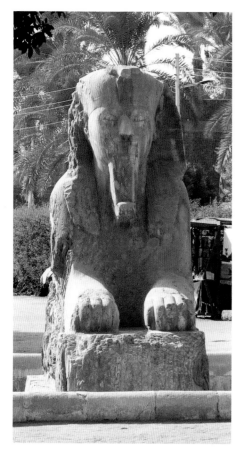

The Grand Egyptian Museum (GEM) statue was originally sited inside the temple complex, to the west of the main eastern gateway entrance. The Great Temple contained a number of large statues of Ramesses II, and remains of colossi have also been found in several locations around the site of the temple.

The king seems to have concentrated on reworking the Ptah temple complex to emphasize his own connection to the gods, and his statues were positioned in front of pylon gateways, at either side of entrances and also at crossroads along sacred routes between temples and other cult sites. There were also large statues of gods, and of Ramesses with gods.

Left: Colossal travertine sphinx of Ramesses II; below: pair statue of Ramesses II and Ptah; right: group statue of Ramesses II, Ptah, and Sekhmet (Memphis Open-Air Museum).

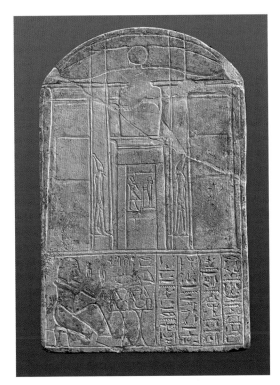

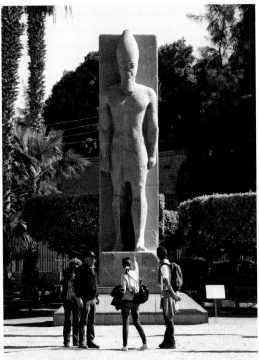

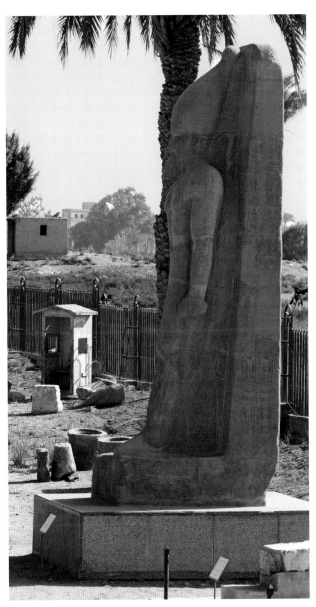

Above left: stela of Ramose (Grand Egyptian Museum), showing two colossal statues either side of a pylon gateway, and a view through into the inner sanctuary of the temple (which may be the small Ptah-Sokar chapel outside the southwestern corner of the temple precinct), where Ramesses II is offering to the god Ptah; left and above: the two Ramesses II statues in white crowns are perhaps those shown on the stela.

City and Statues in Later Times

The city of Memphis remained important throughout the Third Intermediate and Late Periods. Sacred animal cults became very popular, and the Twenty-second Dynasty king Sheshonq I (945–924 BCE) constructed a large embalming house for sacred Apis bulls there. The Twenty-sixth Dynasty king Apries (589–570 BCE) built a huge palace on a mound to the north of the Ptah temple. From here he had a clear view of the surrounding countryside and the Saqqara necropolis.

In around 455 BCE the Greek historian Herodotus visited the Ptah temple at Memphis, where he saw at least two large statues. In Book II of his *Histories* he describes "two statues here forty-one feet high; the northernmost of these the Egyptians call Summer, and the southernmost Winter; the one that they call Summer they worship and treat well, but do the opposite to the statue called Winter."

During the Greek and Roman periods the city continued to grow, and Ptolemaic rulers added to the temples and palaces. By the end of the Roman period, the capital had shifted to a new site across the Nile known as Babylon. Emperor Theodosius I (379–95 CE) began his reign tolerant of other religious practices, but soon took steps to make Christianity the official religion of the Roman Empire. By 390, he had introduced wide-ranging laws banning pagan practices. In 391 he ordered the destruction of the Serapeum (the cult center of the god Serapis) at Alexandria. During the rest of his reign great temples throughout Egypt were closed down, and precious cult statues and other images were melted down and destroyed. The massive temple complex in the center of Memphis no longer functioned.

In 640 CE general Amr Ibn al-As, one of the companions of the Prophet Muhammad, led the Muslim conquest of Egypt. After a siege of the fortress at Babylon lasting for months, a peace treaty was eventually signed in late 641, in what were now the ruins of a palace at Memphis. A new capital city called Fustat was founded, built around the spot where armies had pitched their tents during the siege. By 1000 CE the capital had moved north again, to modern-day Cairo.

Once the temples at Memphis had closed, stone blocks, statues and other objects from the city were taken away and used to build Babylon, Fustat, and then Cairo. The same fate occurred at Heliopolis to the north, cult center of the sun god Re. Inscribed blocks and other objects from these sacred sites are still visible in the medieval buildings of Cairo today.

There are a few scattered references to what remained of Memphis in medieval Arabic sources and reports from western travelers. The site was sometimes linked to the ancient biblical figure of Joseph, and surviving structures were often considered either his prison or his granaries. By the twelfth century CE even the precise location of the once-vast city

Reused ancient blocks in the
Khanqah of Baybars al-Jashankir
(1307–10 CE; photograph by
B. Ezzat); and on a Cairo street
(photograph by I. Goryacheva).

was becoming lost. In around 1170, William of Tyre, archbishop of Jerusalem, wrote a history of the Crusades. His *Historia* drew on eye-witness accounts that also included descriptions of foreign cities: "There exists a venerable city of vast extent where there are still evidences of bygone grandeur, and this the dwellers in those parts positively assert is the Memphis of antiquity."

In 1183 Ibn Jubayr, an Andalusian official traveling through Egypt on his way to Mecca, noted "on the west of the Nile and on our right, the ancient city of Joseph the Truthful, which is now being demolished and its stones removed to the citadel being built at Cairo." In 1204, Abd al-Latif al-Baghdadi, a physician, historian, and philosopher from Iraq, wrote of "wonders" still visible at Memphis "to elude the understanding of the most meditative mind, and to tie the most eloquent tongue that tries to describe them." These included colossal statues, sphinxes, and pedestals resting on enormous bases. "We measured one idol and found that its height, not including the plinth, was over thirty cubits" (15.25 meters). In 1321, historian and geographer Abu al-Fida wrote in his *Taqwim al-buldan* ('A Sketch of the Countries'): "There are wonderful antiquities in Manf [Memphis] now forgotten and destroyed." In al-Maqrizi's *Khitat*, on the history and topography of Cairo written in the first half of the fifteenth century, he describes the town of Memphis and reports: "In this town could be seen two great statues."

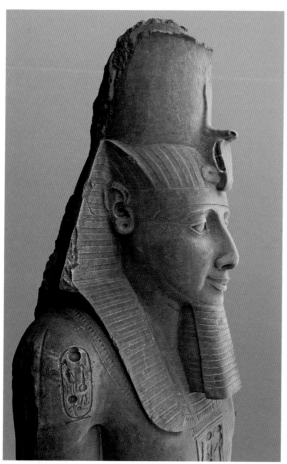

Colossus of Ramesses II found at Memphis in 1821 by Caviglia, who named the large statue Abu al-Hol ('father of terror').

By 1483, when Joos van Ghistele, a Flemish merchant, visited Memphis, he saw "Two walls still standing open, as if they had once belonged to a chapel, . . . before these walls, two statues of giants in hard stones, of an amazing height." One hundred years later in Jacques de Villamont's *Voyages*, published in 1595 and the most popular French travel book of its time, the author described how "on the way we saw on the sand two great colossi" at Memphis.

However, by 1700 the French consul to Cairo Benoit de Maillet reported that "there remain only some shapeless ruins of broken

columns, ruined obelisks and some other destroyed buildings." In 1740, when British writer Charles Perry visited Egypt, he saw "a great quantity of granite, all wrought with hieroglyphs in basso relievo" and "In the courtyard of a house, at the east end of the village, we found the body of a human statue in granite, much bigger than the life."

By the time of Napoleon's French Expedition of 1798–1801, although Memphis was correctly located, almost all evidence of the ancient city has become lost under palm groves and large areas of standing water. Baron Vivant Denon, who was a member of the expedition, recorded "fragments of . . . a colossus of about 35 ft in proportion," while in 1801 British diplomat William Hamilton was "very much gratified by the sight of thirty or forty large blocks of very fine red granite . . . evidently forming parts of some colossal statues."

In 1821 a colossal limestone statue of Ramesses II was uncovered by Giovanni Battista Caviglia, an Italian explorer and Egyptologist who worked in Egypt for a number of British collectors. He named the large statue Abu al-Hol ('father of terror'), and this was later presented to the British government by Muhammed Ali Pasha, viceroy of Egypt and Sudan. There were a number of unsuccessful attempts to raise the statue, including by Alfred Garwood, locomotive superintendent of the Egyptian Railways, and a civil engineer, a Mr Anderson, but it proved too large to move, and until 1887 remained face-down in the excavation trench.

The exciting discovery of the Abu al-Hol colossus led to a period of intense interest in the ruins of the ancient city of Memphis, coinciding with the nineteenth-century growth of the new discipline of Egyptology. Fieldwork has since been carried out at various parts of the site by Egyptian, British, French, German, and American Egyptologists and it remains the focus of archaeological exploration.

5 Discovery of the GEM Statue

n 1852 Armenian engineer Joseph Hekekyan started working at Memphis. He was commissioned to explore the site by Leonard Horner, who was conducting research on "the geological history of the alluvial land of Egypt" for the Geological Society of London. Hekekyan started by sinking a large number of pits running west from the bank of the Nile opposite Helwan. He was looking for patterns of historical Nile flooding, and it was almost incidental that many of his pits exposed statues and other architectural features. During his first year at the site he also conducted excavations around the Abu al-Hol colossus, revealing the original plinth of the statue. This indicated that it had originally stood on the eastern side of the main southern entrance to the Ptah temple enclosure.

After more than two years of careful work at the site, in April 1854 Hekekyan found a red granite colossal statue of a king, and this is the statue that is now on display in the Grand Hall of the GEM, the Grand Egyptian Museum. "The colossus, which measures 15 cubits in height, originally stood facing the east. It fell on its right side, and the body occupied a north and south position, the head being towards the south. In its fall, both of the legs were broken a little above the ankles." Just like the Abu al-Hol statue, the GEM statue's ankles and feet were missing. Hekekyan was able to locate the original plinth of the statue, suggesting that both statues had always lain where they had fallen. The GEM statue had once stood inside the southern gateway of the temple enclosure, on one side of the main eastern processional way leading north into the Ptah temple. He made no attempt to turn or lift the statue, and it remained where it was found.

Some years later, in 1883, the commander-in-chief of the British Army of Occupation in Cairo, General Sir Frederick Stephenson, decided to try once again to raise the

limestone Abu al-Hol statue from its undignified position lying face down in a pool of water. Fundraising was started up to pay for the project, and in 1886 Eugène Grébaut, director of the Antiquities Service between 1886 and 1892, gave twenty pounds from his small budget to pay for moving the granite statue as well.

In 1887 a sketch of the Abu al-Hol statue lying face-down was published in *The Graphic*, a British weekly illustrated newspaper, which described it as "one of the art treasures of England." This was accompanied by a rather mocking article about the inability of the army to raise the statue.

In that same year Major Arthur Bagnold of the Royal Engineers was finally able to lift both statues above the level of the flood waters and install them on raised platforms at the site. A temporary building with viewing platforms was constructed around Abu al-Hol, while the GEM statue was placed on raised blocks.

Bagnold's team was made up of military engineers and local workmen, who "showed much intelligence in the works, and used English wheelbarrows, picks and shovels to good effect." Moving both statues took just over four months, from 17 February to 25 June, and for the GEM statue apparently "the getting out of this statue was a comparatively

The *Graphic* sketch by Henry Wallis of the Abu al-Hol colossus in situ (reproduced in Bagnold 1888).

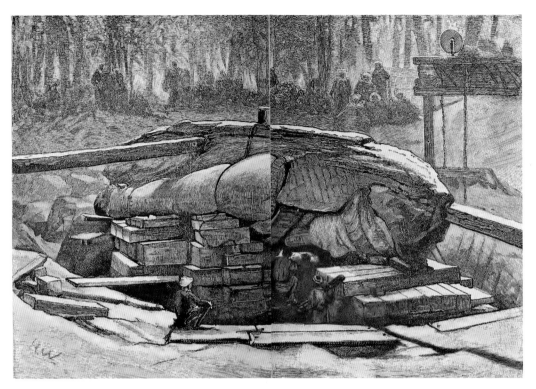

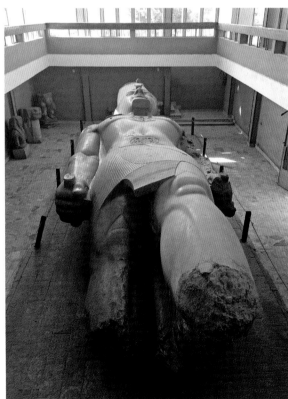

Above: sketch by Henry Wallis (reproduced in Bagnold 1888) showing the Abu al-Hol colossal statue during the lifting process; right: and the statue as it is displayed today in a special building near where it was found at Memphis.

simple affair." They dug around it, down to the original floor of large blocks of stone. The statue was then turned onto its back and raised and placed onto oak rollers running along sleepers. It was then pushed and pulled up a hill to the south, "in reality a mud-brick ruin," where it was placed on three supports in such a way that the inscription on the back pillar could still be seen from below. Bagnold's notes include the information that "The crown and part of the forehead are in a separate block, weighing about 3½ tons, but unfortunately a slice has been wedged off the lower end of the block, probably to form a millstone. The block was originally secured to the head by a huge mortice and tenon joint." The crown was placed upright beside the statue. It is possible that the statue's right leg was broken just below the knee during this move, but this is not mentioned by Bagnold. For the next sixty years, both statues remained on display at Memphis.

After the 1952 Egyptian Revolution, the new government wanted to strengthen national feeling by celebrating the country's rich cultural history. In 1955, Gamal Abdel

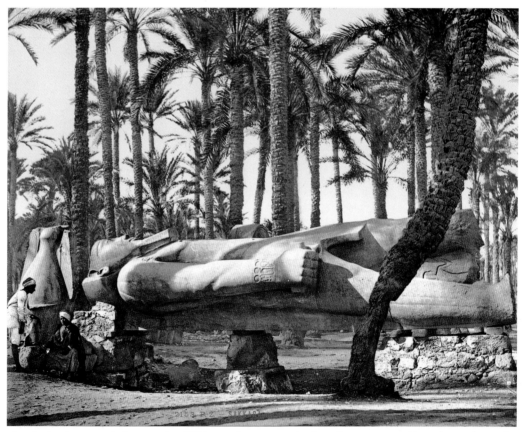

A colorized postcard showing the GEM statue as it was displayed to visitors to Memphis in the early twentieth century.

Nasser (who was prime minister at the time, not yet president) ordered the colossal statue of Ramesses II moved from Memphis to Cairo. On 24 February the municipal affairs minister, Abd al-Latif al-Baghdadi, began transportation, with the statue being slowly driven between the ancient and modern capital cities on a trailer pulled by a tractor.

Nearly ten months of restoration and reconstruction followed, during which time iron bars were inserted inside the body of the statue to hold it together. In November the statue was unveiled in its new location at Bab al-Hadid, the busiest square in central Cairo, next to the main railway station, which was renamed Ramses Square (Midan Ramses). It soon became one of Cairo's most famous landmarks, providing a backdrop for several famous film scenes and songs. The statue also featured on record album covers produced by the Sono Cairo label, a record company nationalized in 1964.

The statue stood for over fifty years amid traffic fumes and shaken by vibrations from passing trains. At the beginning of the twenty-first century the culture minister, Farouk

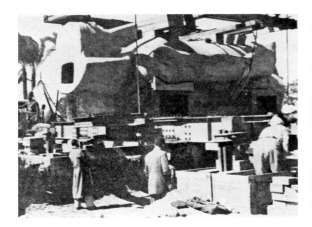
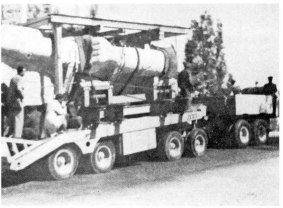
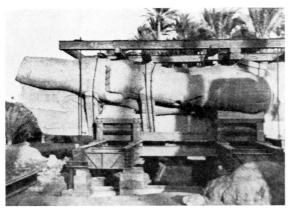

Images of the GEM statue's slow progress from Memphis to Cairo in 1955, recorded by L.A. Christophe in 1955.

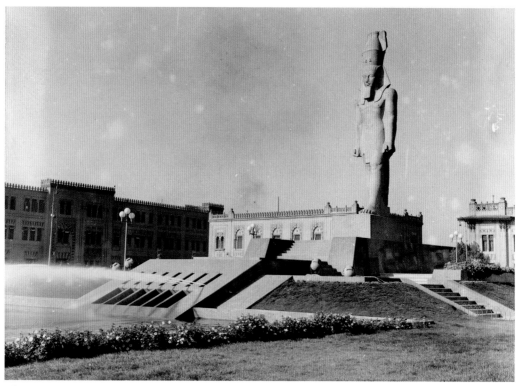

The Ramesses statue standing in Ramses Square, in front of Cairo's main railway station (photograph by Van Leo, courtesy of the Rare Books and Special Collections Library of the American University in Cairo).

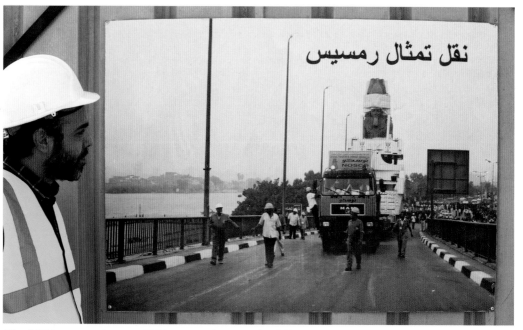

The 2006 move to the new GEM site, as shown at the GEM in January 2018.

Hosni, suggested removing the statue from its location in Ramses Square to protect it from pollution. Several possible new locations were suggested, including returning the statue to Memphis, placing it in Ramaya Square close to the Giza Pyramids, or erecting it at the entrance to the Cairo Opera House. In 2002, it was announced that the Ramesses statue would be moved once again. After years of planning, and a trial run with a full-sized replica, in 2006 the statue was transported by the Arab Contractors company along a specially reinforced road to the GEM building site. The whole operation cost 6 million Egyptian pounds (around US$1 million at the time).

The statue stood on the edge of the building site for the next few years. Then toward the end of 2017, a special temporary road was built, and in January 2018 the statue was finally moved inside the atrium of the new museum building, at a cost of 14 million Egyptian pounds (around US$900,000). Once again, the statue was cleaned and conserved, and for the next few years the building works were finished around it.

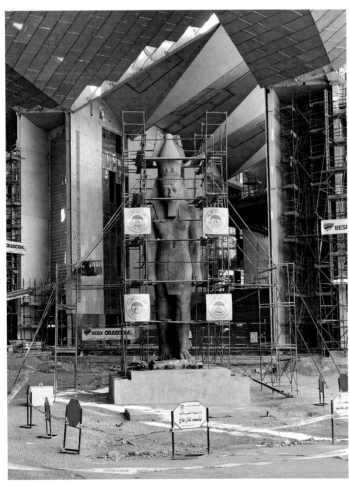

Construction work in the Grand Hall of the Grand Egyptian Museum continuing around the Ramesses statue.

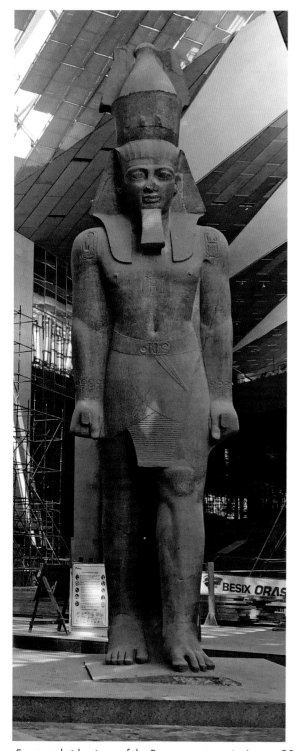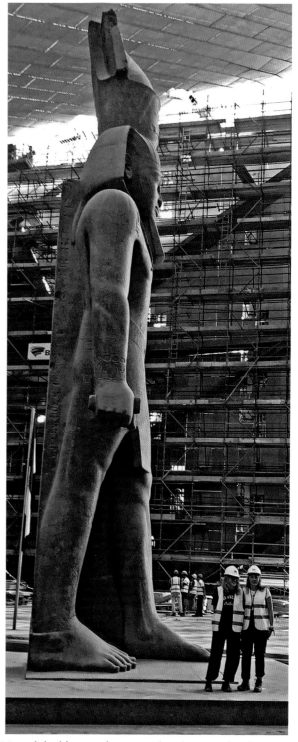

Front and side views of the Ramesses statue in August 2019, with building works to complete the Grand Hall going on around it.

6 Loved by Ptah

As with most monumental stone statuary in ancient Egypt, the GEM statue of Ramesses II is carved in a way that makes the king appear as if he is emerging from the original block of stone. A tall back pillar is visible at the back of the statue and the negative spaces between and behind the king's legs and between his arms and his body are left in place. This artistic device was often used for stone statues. As well as providing structural stability and support, the technique reinforced ideas of the strength and permanence of the sculpture. The king is shown facing forward, with his left leg stepping ahead and both arms down by his sides.

Many colossal statues of Ramesses II, including this one, have similar faces. Different royal studios working with different stone were probably copying a model of the same official portrait, with features based on the king's actual appearance or agreed portrait type. As with modern rulers shown on postage stamps and currencies, a perfect version of the king would have been recognized and understood by a largely illiterate population.

The king wears a *nemes* headcloth. This is a headdress worn only by kings, a piece of striped cloth pulled tight across the forehead and tied into a tail at the back, while two strands or lappets hang down in front of the shoulders. However, recent research at the Grand Egyptian Museum suggests that the *nemes* was actually a more formal and valuable royal headdress constructed out of blue linen and rigid strips of beaten gold that was secured around the king's head with a gold band wrapping around his forehead and tied with strings at the back.

The statue also wears a double crown on top of the *nemes* named "the two powerful ones" *(sekhemty)*, as it combined the white crown of (southern) Upper Egypt *(hedjet)* and the red crown of (northern) Lower Egypt *(deshret)*. The tall part of the *sekhemty* is shown between a pair of *user* signs (an unidentified desert animal head, perhaps a dog

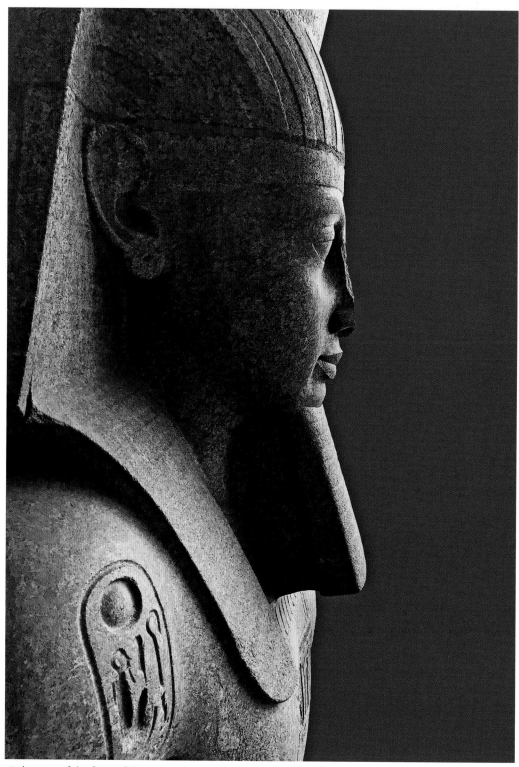

Side view of the face of the statue showing its *nemes* headcloth.

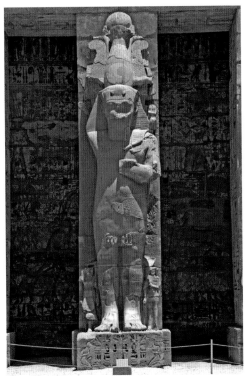

View of the statue's double crown with *user* signs and *maat* feathers.

Statue of Ramesses III wearing a rebus crown spelling out Usermaatre, from his mortuary cult temple at Medinet Habu.

or fox, representing strength and power) and two *maat* feathers (representing truth and the goddess Maat). Originally there was also a sun disc, representing the god Re, on top of the crown. This means that the crown once spelled out one of the king's throne names, Usermaatre. Similar royal rebus headdresses (where different parts spell out the king's or queen's name) appear on statues of the later Ramesses III at Medinet Habu, his mortuary cult temple at Thebes.

A large section of the GEM colossus, between the headband above the eyebrows and the double crown, was missing when the statue was found. This was reconstructed in the 1950s—by copying the other Ramesses colossal statue still at Memphis—with simple vertical stripes to represent a *nemes* headcloth. The tops of two objects from the missing section are still visible on the base of the double crown, and their identity has been a matter of debate among modern scholars. The most likely suggestion is that there was originally a figure of the god Ptah holding his sceptre and standing on a *mer* ('loved by') sign, meaning that the whole crown matched the rest of the statue by actually spelling out "Ramesses Loved by Ptah."

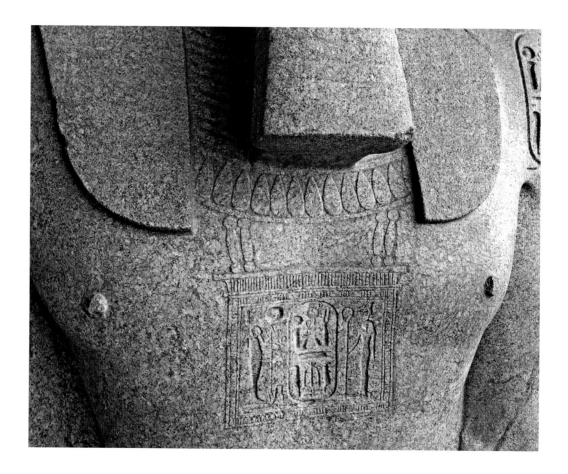

A broad collar is visible between the lappets (the two front pieces either side of the neck) of the *nemes* headcloth. Modeled in raised relief, it suggests five rows of barrel beads alternating with rows of disc beads, with a bottom row of tear-drop-shaped beads. An ornamental chest pectoral hangs below it on a beaded double chain. The central panel of this was recarved by a later king, Ramesses IV.

Ramesses II wears a short, tightly-pleated linen kilt with two side pieces swept up left over right under his belt, and a horizontally pleated central tab reaching almost to his knees. This is held up by a richly decorated belt of tapestry, or perhaps beaten gold, with a central clasp formed of a horizontal cartouche originally containing his name, again re-carved by Ramesses IV. [6.4]

A large dagger is shown tucked into the statue's belt. Daggers had been shown as part of the royal costume since at least the Third Dynasty in the Old Kingdom. A dagger with a falcon head was sometimes shown on New Kingdom kings, and Ramesses II introduced a more elaborate double falcon-headed dagger on many of his standing statues (see the

illustration on page 117). Daggers are sometimes shown tucked into the belt of seated statues, which would have been uncomfortable in real life.

A bull's tail attached to the back of the king's belt is visible between his legs. Kings were often shown wearing bulls' tails, and a gold-and-glass tail engraved with wavy lines to represent hair was found in Tutankhamun's coffin (it had originally been attached to the back of one of two belts his mummified remains were dressed in). From the earliest invention of royal symbols, a bull's tail was used to emphasize the strength and procreative power of the ruler, and royal epithets such as Strong Bull or Mighty Bull were also adopted by many kings.

Royal names in cartouches flanked by rearing cobras all topped with sun discs are engraved into bracelets in sunk relief around each wrist of the statue. These were later recarved by Ramesses IV. In his left hand the king holds a folded handkerchief or piece of fabric, and his right hand holds what may be a papyrus roll case (called a *mekes* container) with slightly concave surface inscribed with a cartouche.

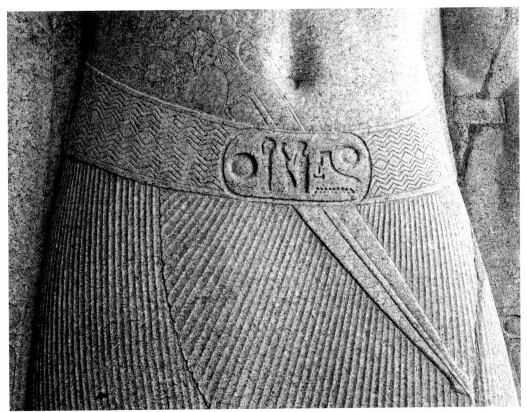

Opposite: the beaded broad collar and pectoral on beaded chain; above: the ornamental belt with cartouche belt buckle and large dagger.

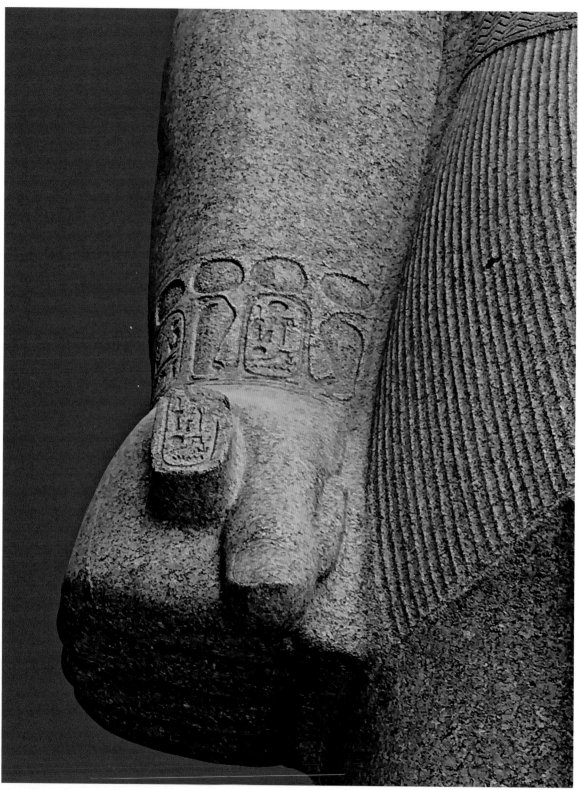

Enigmatic objects held in the statue's hands.

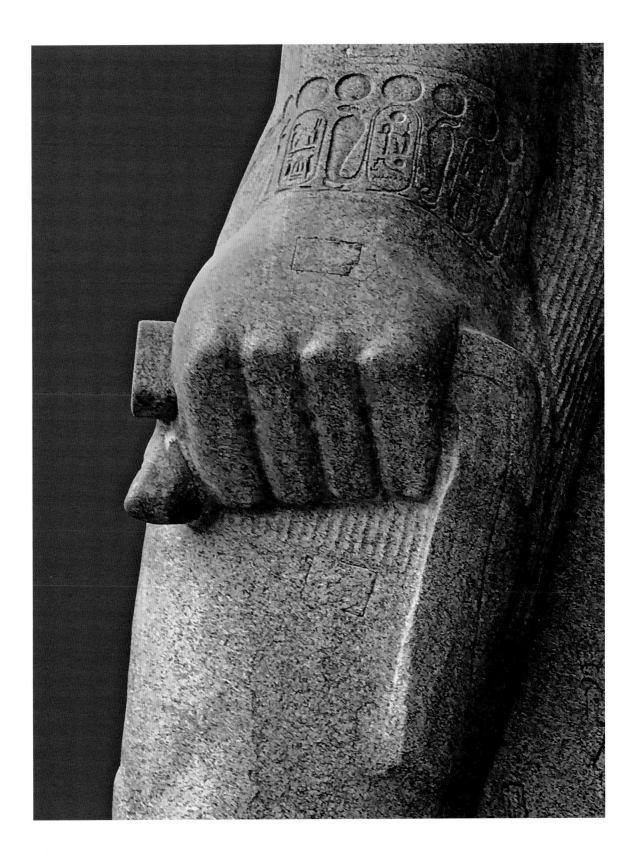

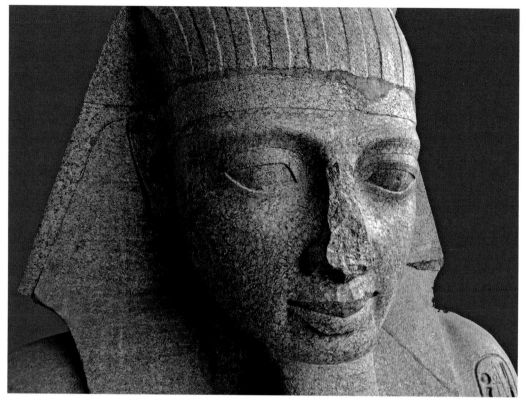

The statue's face.

The statue has a soft, rather oval face with high cheekbones. The king's slightly bulging eyes are almost almond-shaped, and the inner corners dip slightly down. He appears to be looking downward, a common feature in large statues from the Old Kingdom, and again from the reign of Amenhotep III onward, that was achieved by sloping the eyeball inward toward the bottom. He has heavy eyelids (a feature of the post-Amarna period) and a visible kohl line around his eyes and extending outward toward his ears. His eyebrows are clearly defined in raised relief and reach out and down in a curve beyond the outer corner of his eyes. The tip and one nostril of his nose were damaged at some point in the past. Remaining details and comparison with other sculptures indicate that he originally had a fine Ramesside nose. This is one of the defining features of the best representations of Ramesses II, and was usually quite large and slightly curved with a small downward-protruding tip at the end.

He has full lips with well-defined edges that are now slightly damaged, and with the corners curved upward in a faint smile. In order to carve the shape of his mouth into the stone, holes were first drilled in each corner for purchase, and these holes are still visible.

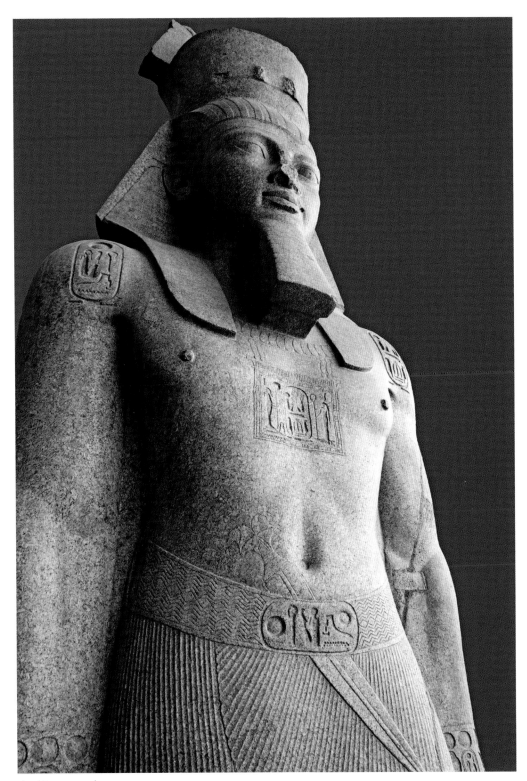

Looking up at the statue.

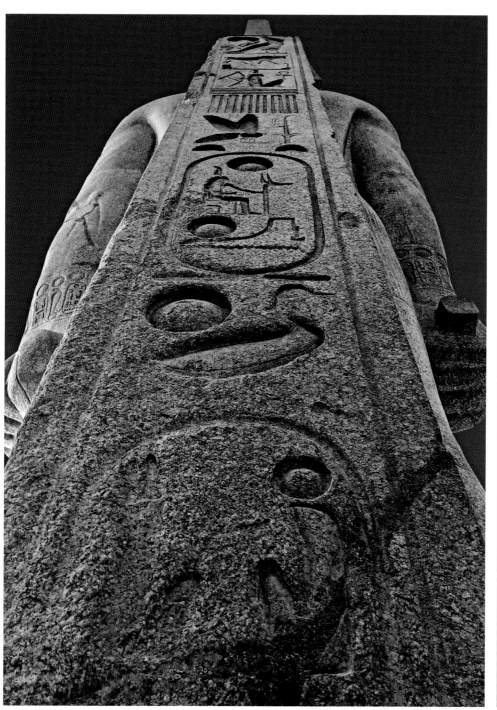
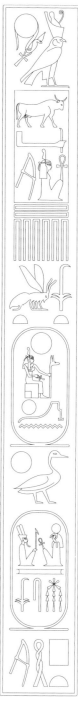

The inscribed back-pillar of the statue containing the names and titles of Ramesses II left unchanged by later kings (drawing by I. Goryacheva).

Deep carving of the corners of the mouth causes shadows that highlight the smile. Two small furrows running down from either side of his mouth define the shape of the chin. A wide, slightly flaring false beard with faint horizontal ridges sits on the front of the king's chin and reaches down his chest. Roughened lines down the edges of his cheeks show the strap that hooked around the king's ears and attached the beard to his chin. There are two visible wrinkle lines in his neck under his chin, which is a Ramesside feature that was also added to earlier statues when they were re-carved during this period. He has small, well-formed ears with a single piercing in each lobe. His eyeballs, eyebrows, and kohl lines all have roughened surfaces, suggesting that they were once either painted or gilded.

It is practically impossible to see any trace of color on the statue today. However, at the time of its move in 1887, Major Bagnold observed that the statue was "covered all over with a fine skin of lime" which may have been the base for pigment. In addition, the bracelet on the statue's right arm "still bears the original red and yellow pigment with which the cartouches had been decorated."

The king's body is elegant and manly, with a tight midriff and abdominal muscles divided above his navel, high-set pectoral muscles with nipples modeled in raised relief, and broad, quite muscular shoulders. The negative space enlarges as his body tapers toward his navel, the section that was usually the narrowest point of Ramesside statues. His arms are tensed and slightly bent, with visible elbow pit depressions.

The statue originally had massive legs, in common with many other Ramesside sculptures. The king's knees are broad, with rounded kneecaps and bulging thigh muscles above. The bones in his lower legs are modeled in relief. When the statue was found, the right leg was missing from below the knee and the left leg from above the ankle; the feet visible today are modern restorations.

There are a number of inscriptions on the statue. Royal cartouches are carved into the belt, bracelets, and pectoral necklace, and two large cartouches are carved onto the front of each shoulder. Many of these were later adapted and partly re-carved by Ramesses IV during the Twentieth Dynasty.

A single strip of inscription carved down the back-pillar contains the names and titles of Ramesses II. It reads: "The Horus, Strong Bull Loved by Maat, King of Upper and Lower Egypt, Usermaatre [Strong in Truth is Re], Setepenre [Chosen of Re], Son of Re, Ramesses Meryamun, Loved by Ptah." The names of the king were left unchanged by later rulers, suggesting that the back of the statue was standing close against the wall or pylon gateway around the temple: the long vertical inscription was probably hard to reach, and perhaps even invisible to human visitors.

Khaemwaset as priest of Ptah holding a naos containing a figure of the god Ptah-Tatenen (Egyptian Museum, Cairo).

7 Ramesses's Children

Two of the king's children are shown on the statue: his son Khaemwaset in the negative space between his legs, and his daughter Bintanath behind his left leg. The inclusion of these particular children with their royal titles can help date when the statue was carved.

Khaemwaset

Prince Khaemwaset ('Rising in Thebes') was the second son of Royal Wife Queen Isetnofret, and the fourth son of his father.

His three elder brothers (Amenhirwonmef, Ramesses, and Prehirwonmef) became soldiers, but, while in his early 20s, Khaemwaset was made *Sem* priest of the god Ptah at Memphis, a senior role that meant he was deputy to the High Priest of Ptah. In Year 16 of Ramesses's reign (around 1263 BCE), he helped to oversee the funeral and burial of the Apis bull. By the time the next Apis bull died in Year 30 (around 1249 BCE) Khaemwaset had decided to bury the bulls together in a special funerary temple and underground gallery of tombs at Saqqara, now known as the Serapeum. For the next thousand years, Apis bulls were buried in extensions to this gallery (now known as the Lesser Vaults), until it became too full and Psamtek I ordered the construction of a neighboring set of underground galleries (now known as the Greater Vaults) at the beginning of the Late Period in 612 BCE.

In addition to the Serapeum and its associated temple, Khaemwaset built a number of new monuments at Memphis, and also restored ancient monuments that he could see around the Memphite necropolis. Just like tourists today, New Kingdom Egyptians liked to take day trips to visit ancient buildings. Many had fallen into disrepair and the names of the kings who commissioned them were often no longer visible. The prince supervised workmen who tidied up, repaired, and restored pyramids, temples, and tombs. He also

added large labels carved into walls that listed the original name of the owner, the name of King Ramesses II, and himself: "Very greatly did the *Sem* priest, prince Khaemwaset, desire to restore the monuments of the Kings of Upper and Lower Egypt." Some of these inscriptions are still visible today, and in later Egyptian literature "Setne Khaemwaset" ("Setne" being a corruption of the word *Setem*, title of the High Priest of Ptah) became a prominent figure in stories of the supernatural dating from the Roman Period.

The Ramesside kings were very keen to associate themselves with earlier rulers, and 'king lists' cataloguing former kings became fashionable in some royal and elite monuments of this period. These contained names of previous kings in their correct sequence, in cartouches (the oval rope-shapes that protected royal names). Such lists were used as a way of remembering and celebrating the past. In state temples these lists honored the Cult of Royal Ancestors, whereby kings also made their own place on future lists safe by giving offerings to rulers before them. With his new projects and renovation works, Khaemwaset concentrated on adapting the whole sacred landscape of the Memphite area to act like a three-dimensional king list, showing the Ramesside kings both honoring and associating themselves with other great kings.

Another of Khaemwaset's roles was to publicize his father's royal jubilees *(Heb Sed)*. These were rituals of royal renewal and regeneration that were celebrated by a king

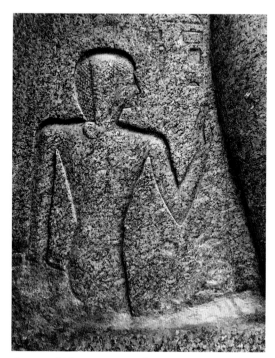
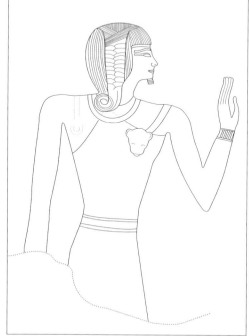

Figure of Khaemwaset in the negative space behind his father's leg.

after thirty years on the throne, and then every three years afterward. Not many kings managed to rule for long enough, and these were rare and special events.

Khaemwaset was in charge of the first five of his father's jubilee *Sed* festivals (in years 30, 33, 36, 39, and 42), and the new West Hall of the Temple of Ptah, which looked toward the large Old Kingdom royal pyramids and other monuments on the Memphite necropolis, was probably built to celebrate one or more of these. It is interesting to note that some of Khaemwaset's 'restorations' included taking materials from existing monuments to build into his new temples, and the West Hall contained reused basalt paving slabs from pyramid courtyards and red granite pyramid casings.

Although much archaeological evidence has disappeared, and modern buildings are now in the way, it is possible that several (now lost) colossal statues of Ramesses II facing westward in front of the pylon gateway of the West Hall may have been able to 'see' and be seen from the newly renovated royal burial and temple sites on the hills of the Saqqara plateau, creating another link between Ramesses II and great kings who had ruled before him.

The figure of Khaemwaset is carved beneath his father deep inside the negative space behind Ramesses's left leg. He is facing forward, with his left hand raised toward his father's calf. Within the sunken outline some of his features are modeled in raised relief. His head and hair are still very clear, while the rest of the detail of his body is harder to see, and his lower legs and feet are lost. The right side of his face is visible, and his straight nose, mouth with a slight smile, small chin, and short beard are recognizable from other representations of the prince. He wears a short round plaited wig with a heavy plaited sidelock with curled end, which usually indicated youth in ancient Egypt but was also part of the uniform of priests of Ptah. He is wearing a modified version of the panther skin of a priest, with a feline head attached to a sleeveless tunic visible on his left breast. There are also visible traces of a thick belt, a broad collar, and a thick bracelet around his left wrist, along with faint outlines of something hanging over his right shoulder.

His name and titles are given as "Kings's son and *Sem* Priest, Priest in the Temple of Ramesses II in the domain of Ptah, Khaemwaset." The Temple of Ramesses II in the domain of Ptah was the still unlocated memorial temple of the king at Memphis, perhaps a parallel institution to the Ramesseum at Thebes.

"Kings's son and *Sem* Priest, Priest in the Temple of Ramesses II in the domain of Ptah, Khaemwaset" (drawing by I. Goryacheva).

Toward the end of his life, and after all the sons of Queen Nefertari and his older full brother Ramesses had died, Khaemwaset became crown prince and heir to the throne. There is no way of knowing if this was a role that he had longed for or indeed wanted at all. He had devoted his adult life to the cult of the god Ptah and to the promotion of his father's status, especially in Memphis. He died before his father in around Year 55 (1224 BCE). Unlike many of his brothers, who were buried together in a family tomb in the Valley of the Kings (KV5), Khaemwaset is thought to have been buried at Saqqara, either in an as-yet undiscovered tomb or with the sacred Apis bulls inside the Serapeum. In 1852, remains of a burial including bones, amulets, jewelry, canopic jars, and a fine golden burial mask were found inside the lesser vaults of the Serapeum. These are now in the Louvre Museum in Paris. Excavations northwest of the Serapeum have also uncovered written evidence of a building dedicated to the *ka* (soul) of Khaemwaset.

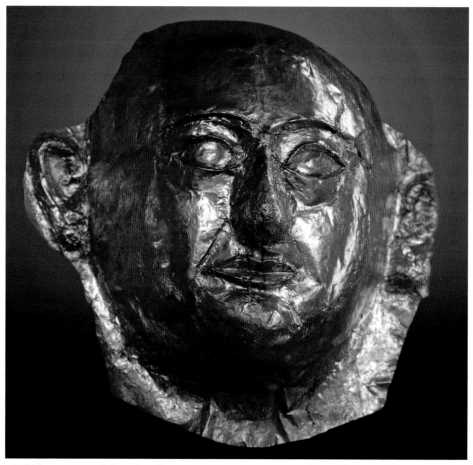

Gold funerary mask found in the Serapeum at Saqqara, perhaps of Prince Khaemwaset.

Bintanath

Ramesses's Great Royal Wife Nefertari and Royal Wife Isetnofret produced a number of children. The king's eldest girl was a daughter of Isetnofret named Bintanath.

The lives of Ramesside queens and princesses are hidden from us now. We do not know where they lived, although it is likely that they traveled between the different royal centers at Piramesse, Memphis, Luxor, and Ghurob in the Faiyum, which was the site of a palace and textile production center. Ramesses II and his many wives had at least a hundred children but we have little idea of their domestic arrangements. Did the children live with their mothers? Did the wives all live together in enormous compounds? We also have no idea how much of their time was spent with the king, and how much was spent alone. We have little idea how independent they were, and whether or not they had their own property and incomes, although there are hints that temples, estates, and farms were gifted to individual family members.

Great Royal Wife Nefertari is shown on a number of royal monuments enjoying state occasions and religious ceremonies, and the smaller Hathor temple at Abu Simbel was built for her. In contrast Royal Wife Isetnofret is almost never shown, although her sons and daughters are displayed, and a now-broken statue of Isetnofret dedicated by her son Khaemwaset describes her as "she who fills the colonnaded hall with the scent of her perfume."

Bintanath's name means 'Daughter of Anath,' a Syrian goddess who was primarily associated with war. Anath was one of a number of similar deities introduced into Egypt from the Levant from the late Middle Kingdom onward. By the Nineteenth Dynasty she was accepted both as a wife of the god Seth and as a daughter of the god Re. Anath seems to have been particularly favored by Ramesses II, who also named a son, Meher-Anath, after her, as well as a horse, dogs, and a sword.

Bintanath was important throughout the reign of her father, first as royal daughter, then as his wife. She became a Royal Wife around Year 25 of her father's reign (1255 BCE), perhaps after the death of Queen Nefertari in Year 24, when her mother Isetnofret was finally promoted to Great Royal Wife. After the death of her mother in around Year 34, Bintanath then became Great Royal Wife, and more images of her were added to statues of her father/husband at temples throughout the Egyptian Empire. Bintanath outlived her father, lasting into the reign of her brother Merenptah, when she eventually died and was buried in the Valley of the Queens. She had a daughter, perhaps also named Bintanath, and it is likely that Ramessses II was also her father. The younger princess may have eventually married her own brother/uncle, King Merenptah.

Bintanath is carved in the negative space outside and behind Ramesses's left leg. She is shown facing forward, with her right hand raised toward her father's leg. Within the

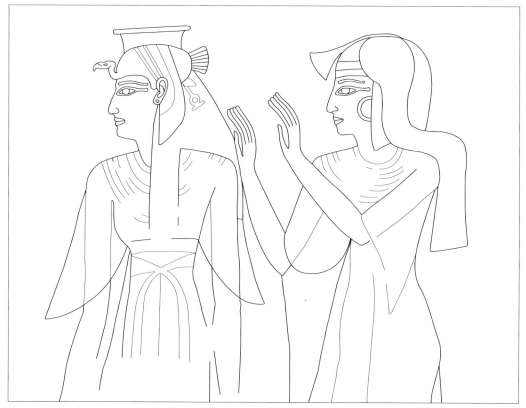

Bintanath and her daughter, perhaps also named Bintanath, from her tomb in the Valley of the Queens (QV 71).

sunken outline of her figure, various features are modeled in raised relief, which is a more skilful sculptural technique, especially when carving very hard granite. She is beautifully modeled, and some very fine details of her hair and clothes are still visible.

It is not really clear exactly how close the depictions of ancient Egyptians are to how they actually looked in real life. It is most unusual to find images of anyone looking sick or old or ugly, even though medical analysis of human remains tell a very different story.

The way clothes are shown also does not particularly match actual examples of clothes that have been found carefully stored in tombs. From the Old Kingdom until the middle of the Eighteenth Dynasty, women are usually shown barefoot in tight, sleeveless floor-length tube dresses that would have been very hard to walk in. However, laundry lists and material remains often include shoes, loincloths, and loose tunics with sleeves. From the mid-Eighteenth Dynasty onward, elite female clothing shown in art becomes much more elaborate, and by the Amarna Period women are shown with layers of clothing. In paintings these are often magically transparent so that the full outline of the female body

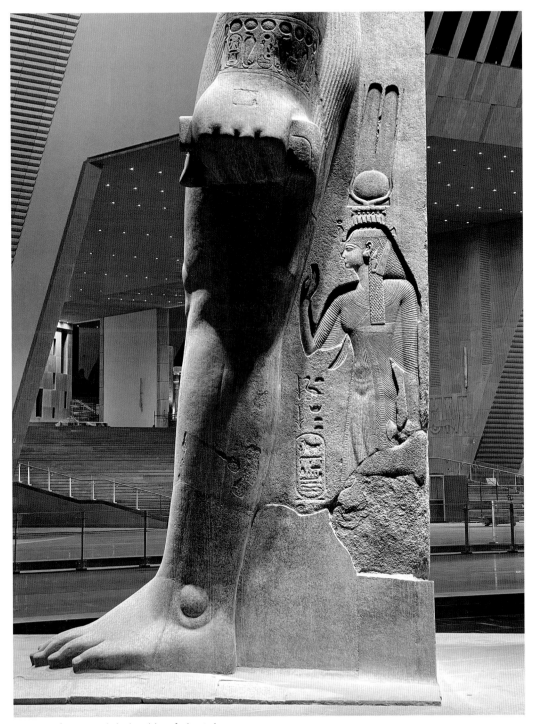

Figure of Bintanath behind her father's leg.

is visible, while in royal and elite female statuary dresses cling to every surface of their bodies. This is almost certainly related to the function of artistic representation, especially in tombs, where the true and most complete version of everything was depicted. It may also reflect cultural norms in a way that is no longer apparent to us, but it interesting to note that the same level of transparency was not applied to men's outfits.

Bintanath wears a long wig of plaits or corkscrew curls with twisted ends. Her hairstyle is divided into three, with two sections brought forward over her shoulders (only one is visible) and the mass of her wig hanging down behind. A small tab of her own hair is visible in front of her left ear. An elaborate diadem or jeweled headband sits horizontally around her wig and is tied at the back, with a single streamer visible hanging down behind her left ear. This is edged with a cobra wearing the white crown of Upper Egypt. Her forehead has a rearing *uraeus* cobra wearing a sun disc and horns, and this appears to have its tail wrapped around her headband, perhaps for stability. A round *modius* crown surrounded with more rearing cobras, each with a sun disc on its head, sits on top of her wig. This crown is topped by two tall horns around a sun disc and two tall feather plumes.

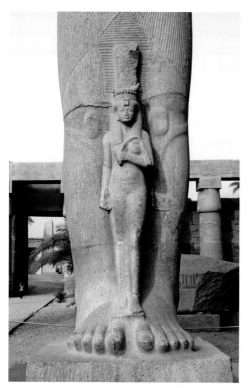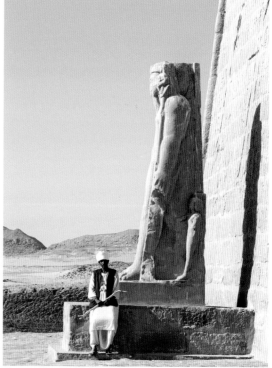

Bintanath in front of Ramesses II's legs at Karnak; and beside him on a colossal statue at the Amun temple in Wadi al-Sebua in Lower Nubia, constructed between Years 35 and 50 of her father's reign.

She wears large round ball earrings, and an elaborate beaded broad collar with four rows of barrel beads and a bottom row of teardrops. She also has pairs of thick armlets and bracelets around her forearms and wrists. She holds a papyrus umbel (flower cluster) in her left hand.

Her body is covered in finely pleated material, either a separate dress and shawl or a single garment that is folded and tied around her body. Her arms and shoulders are covered with a long piece with decorative fringing that is tied in an elaborate knot under her right breast. The rest of this piece (or a separate dress) hangs down her body in vertical pleats, with the fringed edge visible. Two ends of a fancy belt with horizontal stripes tied high around her waist hang down in front of her dress. This was the most fashionable outfit for royal women during the reign of Ramesses II and can also be seen on statues of his wives and his mother Tuya. The hem of Bintanath's dress and her feet are missing.

On this statue her titles are given as "King's Daughter and King's Wife" but not yet Great Royal Wife. This indicates that her image was almost certainly carved and inscribed at some time between Years 25 and 35, so finished in 1250 BCE.

The locked doorway of Bintanath's tomb (QV 71).

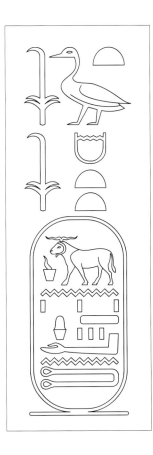

"King's Daughter and King's Wife" (drawing by I. Goryacheva).

8 Additions by Ramesses IV

R amesses II was succeeded by his thirteenth son Merenptah (1213–1203 BCE), who came to the throne because his twelve older or more senior brothers had died before their father. Perhaps already in his sixties, Merenptah built two temples and a palace at Memphis, commissioned some new statues, added his name to existing statues and monuments, and began taking stone and other materials from the mortuary cult temple of Amenhotep III at Luxor to build his own. He was succeeded in quick order by his son Sety II (1203–1194 BCE) and a rival king from the south called Amenmesse (1203–1200 BCE), then Sety II's son Ramesses-Siptah (1194–1188 BCE), and finally by Queen Tawosret (1188–1186 BCE). The first ruler of the Twentieth Dynasty was a shadowy figure of unclear origins called Sethnakht (1186–1184 BCE), who ruled for two years before being succeeded by his son Ramesses III (1184–1153 BCE).

Ramesses III consciously modeled himself and his reign on Ramesses II, giving his sons the same names in the same order as those of Ramesses II. His successful military campaigns in Libya and along the north coast kept new enemies called the Sea Peoples at bay. These invaders may have brought to an end the civilizations of many of Egypt's northern neighbors, including the mighty Mycenaean and Hittite empires. These and other battles in Syria and Nubia were documented in reliefs on the exterior walls of his enormous mortuary cult temple that was modeled on the Ramesseum. Now known as Medinet Habu, this temple was largely finished and decorated by Year 12. Ramesses III also added new temples to the Amun complex at Karnak. It is known that he expanded the Ramesside capital city at Piramesse, but there is little remaining evidence for any of his building works in the north.

Ramesses IV (1153–1147 BCE) was the fifth son of his father Ramesses III, and became heir in Year 22 after his four older brothers had died. He is shown in a procession of

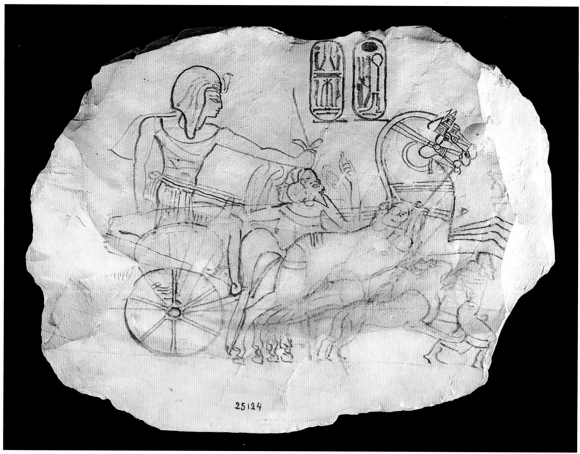

An ostracon of Ramesses IV in his chariot, found in the debris in the Valley of the Kings (Egyptian Museum, Cairo).

princes on the walls of his father's Medinet Habu temple, and in the forecourt of a Ramesses III temple in the complex of the Great Temple of Amun at Karnak. He seems to have taken an increasingly important role in the rule of Egypt toward the end of his father's reign. In Year 27, for example, he is shown as being responsible for the appointment of the new high priest of the goddess Mut at Karnak called Amenemopet. Ramesses III was assassinated at the instigation of a secondary wife called Tiye and her son Pentawere, who conspired with others to kill the king by cutting his throat, and the reign of Ramesses IV seems to have been greatly overshadowed by this appalling event. One of the ways he tried to prove his right to the throne seems to have been to carve his cartouches as widely as possible at sites and monuments throughout Egypt.

In the first year of his reign, Ramesses IV commissioned the 'Festal Stela' that was engraved onto the eastern wall of the courtyard between the seventh and eighth pylons

in the Great Temple of Amun complex at Karnak. This describes his visits to the temples of Re at Heliopolis, Ptah at Memphis, and Amun at Thebes, and says his cartouches in the Ptah temple were inscribed "in the god's own writing."

During the rest of his reign Ramesses IV linked himself to his predecessors by inscribing his name and titles in a number of temples built or improved by Ramesses II and Ramesses III. He began construction of his tomb in the Valley of the Kings and an enormous mortuary cult temple that was never completed, and which was later usurped by both Ramesses V and Ramesses VI. He also carved his name onto many existing statues and obelisks. At Karnak he added his name to obelisks of Thutmose I and the base of a colossal Ramesses II statue. Ramesses IV may have spent much of his time in his royal palace at Memphis, and at the Great Ptah temple at Memphis he added his name and titles to the GEM Ramesses statue.

The GEM statue already had inscriptions from Ramesses II on the back pillar, the belt buckle, above the prince and princess, and on a pectoral hung by an ornate chain around his neck. Many of these were redrawn both by adding some signs and changing others by covering them with plaster. Close examination of the belt buckle and pectoral reveal faint traces of the original signs beneath.

Ramesses IV also added his cartouches onto the front of each shoulder of the statue, as well as on thick bracelets around each wrist and down one side of the statue's back pillar.

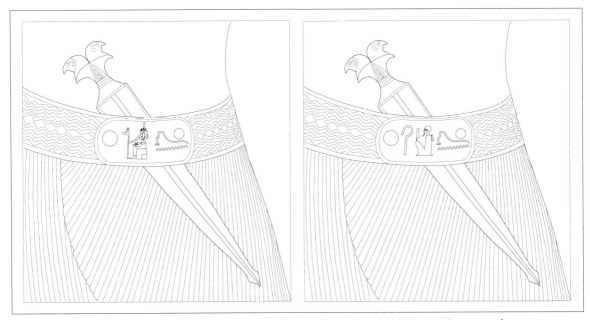

Cartouche on the belt buckle of Ramesses II, before (left) and after (right) the change to the name of Ramesses IV.

The cartouches around the statue's wrists use versions of the king's names adopted in the second year of his reign, when he often added Maaty ('the True One') to his birth name Ramesses Meryamun ('Loved by Amun'). This suggests there was some competition for his position as king. At the same time his throne name expanded to become Heqamaatre ('Ruler of truth is Re') Setepenamun ('Chosen by Amun').

Because this statue was in the great temple of Ptah, the king tactfully changed the god's name in Setepenamun, and so the cartouches read Heqamaatre Setepenptah ('Chosen by the god Ptah') instead.

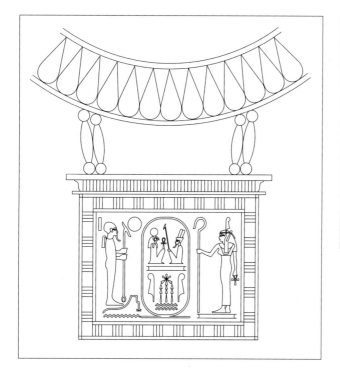

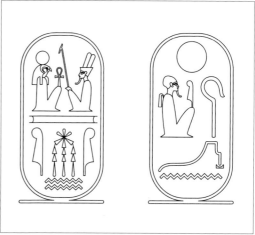

Ramesses IV's name on the pectoral and his cartouches on thick bracelets naming him as chosen by Ptah (drawings by I. Goryacheva).

Timeline of the GEM Statue

1250 BCE Ramesses II commissions a colossal statue of himself from red granite quarries in Aswan, to stand as a pair with another statue at or near the east gateway of the Great Ptah Temple at Memphis, with his daughter Bintanath shown as queen (after Year 25) and son Khaemwaset shown as *Sem* priest of Ptah and High Priest of Ramesses II's memorial temple at Memphis (before Year 55) between his legs.

1153–1147 BCE King Ramesses IV adds his name to the statue.

455 BCE The Greek historian Herodotus visits Memphis and describes "two statues here forty-one feet high; the northernmost of these the Egyptians call Summer, and the southernmost Winter."

Seventh century CE **onward** Memphis city and temples are completely plundered to build Cairo, while various medieval sources still make references to colossal statues lying about at Memphis.

1821 A limestone colossus is discovered at Memphis by Giovanni Battista Caviglia. This statue was presented to the British government by Muhammad Ali Pasha, but no one could work out how to get it to London.

1854 Armenian engineer Joseph Hekekyan finds the red granite colossus now known as GEM 1 while working for Leonard Horner, who was conducting research on

"the geological history of the alluvial land of Egypt" for the London Geological Society.

1886 Commander-in-Chief of the British Army of Occupation in Cairo General Sir Frederick Stephenson decides that the limestone statue is British enough to be rescued from its undignified position (lying face down in a pool of water). Eugène Grébaut, director of the Antiquities Service from 1886 to 1892, gives twenty pounds from his slender budget to pay for moving the GEM statue.

1887 Major Arthur Bagnold RE lifts both statues out of floodwaters and installs them on raised platforms at the site, (possibly breaking one of the legs of the GEM statue, though his notes do not say so). A building with viewing platforms is constructed around the limestone statue; the GEM statue is placed on raised blocks.

1955 Under directions from Prime Minister (not yet President) Gamal Abdel Nasser, Municipal Affairs Minister Abd al-Latif al-Baghdadi moves the GEM statue to Bab al-Hadid, in front of Cairo's main railway station, which is renamed Ramses Square.

2005 Plans are made to move the statue from Ramses Square to the new Grand Egyptian Museum.

2006 The statue is moved to the GEM site, where it remained on the edge of the building plot.

2017 The construction firm Arab Contractors prepares the statue for installation, protecting it with foam and building a temporary road leading into the museum building.

2018 The statue is installed in the GEM atrium.

2022 The GEM opens to the world.

Glossary

Amun: The chief national god of New Kingdom Egypt. Originally a local god in Luxor, his main cult center was the Great Temple of Amun at Karnak in Thebes (modern Luxor). Amun (whose name means 'the hidden one') was already powerful during the Middle Kingdom, at which point his identity began to merge with the sun god Re of Heliopolis (now a Cairo suburb) in the north. During the New Kingdom the composite figure **Amun-Re** was the most important god in Egypt, becoming king of all the gods and lord of heaven, while Thebes became known as Heliopolis of the south.

Ankh: Hieroglyphic sign for life, shaped like a T with a loop on top, often shown being offered by gods to the king, also used as a decorative pattern.

Apis Bull: Sacred symbol of the god Ptah, a specially selected animal that lived in splendor in the temple precinct at Memphis. Each one was mummified after death and buried in the Serapeum at Saqqara.

Birth Name (nomen): The name that kings were given at birth and the one that modern scholars use to refer to ancient rulers.

Cartouche: An oval frame, in the form of a tied rope, surrounding the birth and throne names of the king written in hieroglyphs. Associated with the *shen* sign, which meant protection.

Dynasty: A series of rulers most often descending within the same family. First recorded by Manetho, who divided Egyptian history into thirty dynasties.

Hieroglyphs: From the Greek ('sacred symbols'), a script divided into pictograms (of objects), ideograms (of ideas), and phonograms (of sounds). It was used from the Predynastic to the Roman periods for formal inscriptions and was written both horizontally and vertically.

Hathor: A goddess worshiped throughout the country, related to love, sexuality, and music; portrayed as a woman with cow horns or ears, or as a cow.

Horus: Falcon god, son of Osiris and Isis, particularly associated with the reigning king, who was often referred to as the Horus.

Isis: Protective goddess, wife of Osiris and mother of Horus. Her name was also used as a pun as it was similar to the word for a throne.

Ka: The soul or life force of a person that continued to exist after someone's death.

Lower Egypt: The northern part of Egypt, above Memphis, including the Nile Delta.

Maat: An abstract concept related to truth, justice, order, balance, and rightness in the universe, personified by the goddess Maat, recognizable by the feather on her head.

Manetho: Egyptian priest and scholar who wrote a history of Egypt in around 300 BCE. His division of kings into thirty dynasties is still used as the framework for ancient Egyptian history.

Nemes headcloth: Royal headdress tied around the forehead, fanning out at the sides and with two sections hanging down in front of the king's shoulders.

Nubia: Region immediately south of Aswan. Largely controlled by Egypt during the New Kingdom.

Obelisk: Narrow four-sided standing stone with a pyramid-shaped top often covered in gold to reflect the first rays of the sun. Obelisks were solar symbols sacred to the sun gods Re, Amun-Re, and Atum.

Opet Festival: Annual celebration during which statues of the gods Amun, Mut, and Khonsu were carried in sacred boats from Karnak Temple to Luxor Temple and back again.

Osiris: God of the Dead and ruler of the underworld.

Pharaoh: The king of Egypt. A Greek term coming from the Egyptian word for 'palace' (*per-aa*); from the New Kingdom onward it was also used to describe the king himself.

Ptah: Creator god and patron god of artists and craftspeople.

Pylon: Large ceremonial gateway at the front of a temple consisting of two tapering towers linked by a bridge. Also sometimes used for palaces, and usually decorated with images of gods and pharaohs.

Re: Sun god, and the oldest and most imortant god associated with kingship. He was often linked with other gods (Amun and Horus in particular).

Sed Festival: A ritual of regeneration and renewal for the king, in theory celebrated in Year 30 and then every three years afterward.

Stela: Most commonly a round-topped slab of stone decorated on one side with inscriptions and images. Commemorative stelae were used by kings to record specific gifts, actions, and events.

Solar and Lunar Boats: Reflecting the riverine nature of Egyptian society, these were boats used by gods and the dead pharaoh to travel through the heavens and the underworld. Large models of boats, with kiosks housing statues of gods, were carried on the shoulders of priests during religious processions.

Throne Name (prenomen): A royal name given at the time of coronation, and the name most often used in official inscriptions and international correspondence.

Upper Egypt: Southern part of Egypt, below Memphis to south of Aswan. Includes the Nile Valley and desert edges either side of the river.

Uraeus snake: A symbol worn on the front of a royal crown or headdress representing a fire-spitting cobra protecting the king.

Vizier: During the New Kingdom, one each for Upper and Lower Egypt, these were chief ministers and the next most powerful people after the king.

Bibliography and Further Reading

Translations of all ancient quotes in this book come from:

Breasted, J.H. 2001. *Ancient Records of Egypt*, volume 3: *The Nineteenth Dynasty*. Chicago: University of Illinois Press.

Caminos, R.A. 1954. *Late Egyptian Miscellanies*. London: Oxford University Press.

Kitchen, K.A. 1999. *Ramesside Inscriptions: Ramesses II, Royal Inscriptions*, volume II. Oxford: Blackwell.

Lichtheim, M. 2006. *Ancient Egyptian Literature*, volume II: *The New Kingdom*. Berkeley: University of California Press.

A good book about Ramesses II is:

Kitchen, K.A. 1983. *Pharaoh Triumphant: The Life and Times of Ramesses II*. Warminster: Aris and Phillips.

Other books and catalogues include:

Bleiberg, E. and R. Freed (eds.). 1991. *Fragments of a Shattered Visage: The Proceedings of the International Symposium of Ramesses the Great*. Memphis, TN: University of Memphis.

Freed, R. 1987. *Ramesses the Great, His Life and World: An Exhibition in the City of Memphis*. Memphis, TN: University of Memphis.

Habachi, L. 1969. *Features of the Deification of Ramesses II*. Gluckstadt: J.J. Augustin.

James, T.G.H. 2002. *Ramesses II*. London: White Star.

Thomas, S.C.E. 2003. *Rameses II: Pharaoh of the New Kingdom*. New York: Rosen.

For information about the city of Memphis through the ages, see:
El Daly, O. 2000. *Egyptology, The Missing Millennium: Ancient Egypt in Medieval Arabic Writings*. London: Routledge.
Jeffreys, D.G. 1985. *The Survey of Memphis I: The Archaeological Report*. London: Egypt Exploration Society.
Jeffreys, D.G. 2010. *The Survey of Memphis VII: The Hekekyan Papers and Other Sources for the Survey of Memphis*. London: Egypt Exploration Society.
Petrie, W.M.F. 1909. *Memphis I*. London: School of Archaeology in Egypt.
Wegner, J. and J.H. Wegner. 2015. *The Sphinx that Traveled to Philadephia: The Story of the Colossal Sphinx in the Penn Museum*. Philadelphia: University of Pennsylvania Museum of Archaeology and Anthropology.

For general works on the history and culture of ancient Egypt, see:
Lehner, M. 1997. *The Complete Pyramids*. London: Thames and Hudson.
Reeves, C.N. and R.H. Wilkinson. 1996. *The Complete Valley of the Kings*. London: Thames and Hudson.
Shaw, I. 2003. *The Oxford History of Ancient Egypt*. Oxford: Oxford University Press.
Shaw, I. and P.T. Nicholson. 1995. *The British Museum Dictionary of Ancient Egypt*. London: British Museum Press.
Silverman, D.P. (ed.). 1997. *Ancient Egypt*. Oxford: Oxford University Press.
Snape, S.R. 2014. *The Complete Cities of Ancient Egypt*. London: Thames and Hudson.
Wilkinson, R.H. 2003. *The Complete Gods and Goddesses of Ancient Egypt*. London: Thames and Hudson.

Works cited:
Abu al-Fida. 1848. *Taqwim al-buldan* from *Geographie d'Aboulfeda*, tr. M. Reinaud. Paris: Imprimerie Nationale.
Abd al-Latif al-Baghdadi. 2021. *A Physician on the Nile: A Description of Egypt and Journal of the Famine Years*, tr. T. Mackintosh-Smith. New York: New York University Press.
Bagnold, A.H. 1888. "Account of the Manner in which Two Colossal Statues of Ramesses II at Memphis Were Raised." *Proceedings of the Society of Biblical Archaeology* 10, pp. 452–63.
de Villamont (C. Burri and S. Sauneron, eds.). 1971. *Voyages en Égypte: des années 1589, 1590 et 1591. Le Vénitien anonyme. Le Seigneur de Villamont. Le Hollandais Jan Sommer*. Cairo: Institut Français d'Archéologie Orientale.

Christophe, L.A. 1956. "Quatre Enquètes Ramessides." *Bulletin de l'Institut d'Egypte* 37, 5–38.

de Maillet, B. 1735. *Description de l'Egypte*. Paris.

Denon, V. 1803. *Travels in Lower and Upper Egypt*, tr. A. Aikin. London: Longman and Rees.

Habachi, L. 1965. "The Graffito of Bak and Men at Aswan." *MDAIK* 20.

———. 1973. "The Two Rock-Stelae of Sethos I in the Cataract Area Speaking of Huge Statues and Obelisks." *BIFAO* 73, pp. 113–25.

Hamilton, W.R. 1809. *Remarks on Several Parts of Turkey*, Part I: *Aegyptiaca*. London: Cadell and Davies.

Hekekyan, J. 1863. *A Treatise on the Chronology of Siriadic Monuments*. London.

Herodotus. 1954. *The Histories*, tr. A. de Sélincourt. London: Penguin Classics.

Ibn Jubayr. 1952. *The Travels of Ibn Jubayr*, tr. R.J.C. Broadhurst. London: Jonathan Cape.

al-Maqrizi. 1895. *Description topographique et historique de l'Egypte*, tr. U. Bouriant. Paris: Leroux.

Newberry, P.E. 1894. *El Bersheh I: The Tomb of Tehuti-Hetep*. London: Egypt Exploration Fund.

Perry, C. 1743. *A View of the Levant: Particularly of Constantinople, Syria, Egypt, and Greece*. London: Woodward and Davis.

van Ghistele, Joos. 1976. *Voyage en Égypte 1482–1483*, tr. R. Bauwens-Préaux. Cairo: Institut Français d'Archéologie Orientale.

William, Archbishop of Tyre. 1943. *A History of Deeds Done Beyond the Sea*, tr. E. Babcock and A. Krey. New York: Columbia University Press.